C000180647

SILVERSTONE CIRCUIT
THROUGH TIME
Anthony Meredith &
Gordon Blackwell

AMBERLEY PUBLISHING

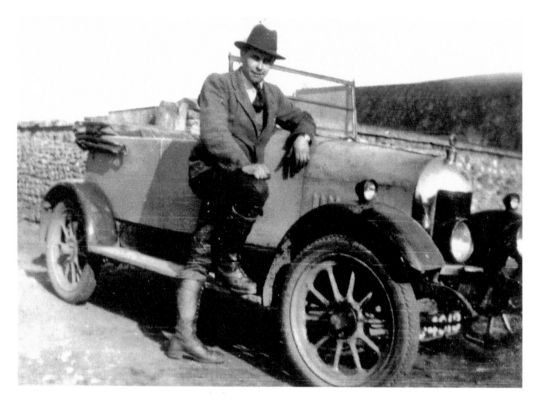

Smith Churchill (with pre-war Morris 'Chummy') – a great Silverstone character.

First published 2013

Amberley Publishing
The Hill, Stroud, Gloucestershire, GL5 4EP
www.amberley-books.com

Copyright © Anthony Meredith & Gordon Blackwell, 2013

The right of Anthony Meredith & Gordon Blackwell to be
identified as the Author of this work has been asserted in
accordance with the Copyrights, Designs and Patents Act
1988.

ISBN 978 1 4456 0636 1 (print)

British Library Cataloguing in Publication Data.
A catalogue record for this book is available from the
British Library.

Typesetting by Amberley Publishing.
Printed in Great Britain.

Introduction

Silverstone in the 1930s

No one in the village in the 1930s could ever have imagined that a glamorous Grand Prix motor racing circuit would one day make the name of Silverstone known throughout the world. It would have been unthinkable. There was something reassuringly static about the place. In the distant past, it was true, a Benedictine abbey had once been built close by; so too a royal hunting lodge, and a palatial estate with the finest of landscape gardens. But the village had long been basking in untroubled anonymity along the secluded borders of Northamptonshire, Buckinghamshire and Oxfordshire.

Not far away lay the countryside that had inspired Flora Thompson's *From Lark Rise to Candleford*. Parts of Silverstone, in its pre-war form, had more than a touch of Lark Rise; both were surrounded in all directions by unspoilt fields and woodlands. Candleford, too, was partly based on the small market town of Buckingham, only 7 miles up the rustic Dadford Road. The whole district was 'pasture country', as another local writer, T. H. White, described it. 'There is scarcely any industry in it,' wrote White in 1937, 'and its people are gentle. There is nothing remarkable about this country. We are hunted over by good packs of hounds. We don't have much in the way of hills, and therefore little in the way of valleys.' Even the first Silverstone bypass, built in the 1930s, failed to change the atmosphere of a village still dependant on farm and forest, unperturbed by the Austin Sevens and Morris Eights chugging slowly along on the road between Longbridge and Cowley.

Then came the Second World War, and the unthinkable drew a little closer.

The Wartime Airfield

In 1942 the RAF commandeered a large site centred around a farm on the edge of the village whose name recalled a lost local landmark, Luffield Abbey. A massive transformation, costing over £1 million, speedily occurred. Trees were chopped down; hamlets disappeared; Chapel Green, proud of its Methodist links, was no more; so too the cluster of houses built where a fourteenth-century chapel once honoured St Thomas à Becket. (Today's famous corner, near this site, should surely be spelt Becket's rather than Beckett's, or even worse Becketts?) The locals could only look on in awe. Keith Coleman of Lillingstone Dayrell recalled:

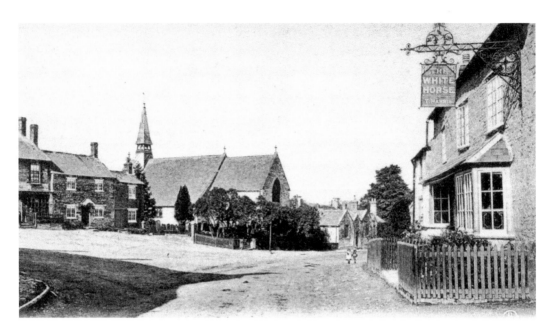

Silverstone Village

In the track's early days the connection with the village was very strong, and drivers flocked to the White Horse (*right*). Mike Hawthorn, the 1958 world champion, was typical: 'We always used to have bread and cheese and pickled onions.' The landlord's wife's pickle, declared Hawthorn, was particularly good. Top drivers in those days were less anxious about diet. 'Once she made us a Yorkshire pudding, which went down very well.'

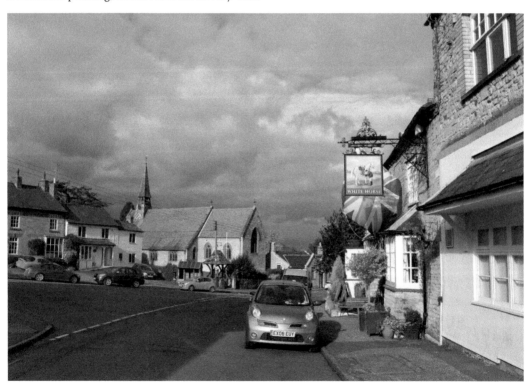

'My father, who was head woodsman on part of the Whittlebury estate, had to go with the man from the Ministry to value the trees that would have to be felled. I went as well and remember the camouflaged Morris Ten we rode in. It was quite an occasion to ride in a car in those days.'

Bomber Command's newest airfield was officially opened on 20 March 1943 as a base for 17 OTU (Operations Training Unit). Fifty-four Wellingtons were stationed there by June, most of them fairly weary and battle-scarred, together with a few smaller planes – Ansons, Martinets and Lysanders. These were all crucial components in the short training course that 17 OTU provided for each new intake of 600 airmen, who would arrive as strangers to each other but leave only six weeks later as part of a six-man bombing crew, ready for active service.

The operational side of the airfield was separated from the non-operational by the narrow road that led to Buckingham via Dadford. Three intersecting runways and their perimeter road were built to the east of it. To the east, too, sandwiched between runways and road, was a dense collection of new buildings: the control tower, an 80,000-gallon water tank tower, two massive hangars, depots for petrol and oil, latrines, fire-tender headquarters and many workshops, plus stores for anything from sand and salt to parachutes. On the runways' far side were three more hangars: one off the perimeter road between Copse and Maggots, and two more on the outside of what was to become Hangar Straight. Bombs were stored south of the runways, well away from human habitation, in what is now the Silverstone Rally Centre.

West of the Dadford Road (where Eddie Jordan's factory was to be built in 1991) was a sprawling new 'village', separated into several different sites, providing accommodation for most of the 2,000 airmen and 200 WAAFs. Nearest to the road was Site 2, an instructional area where the new arrivals spent their first two weeks without any flying. There were three key buildings. In a two-storey 'Bombing Teacher', moving images were projected from above onto a white floor to simulate targets. The bomb aimer, from an enclosed side gallery, would send course corrections by wireless to his pilot, who was seated elsewhere and doing his best to adjust the bomb run to changing wind speeds and directions. Another two-storey building, the 'Turret Instructional Trainer', featured a central gun turret surrounded by white walls on which images of attackers were projected. Realism was enhanced by sound effects from loudspeakers. But most important was the 'Airmanship Hall' where the crews, positioned at their individual stations in the fuselage of an old Wellington, developed a team ethic as they relentlessly practised routine and emergency procedures. Nothing now survives of this education area, though the 'Airmanship Hall', as large as a gymnasium, did last for over forty post-war years, occupied for a time by a sand-blasting company.

The trainees' remaining four weeks were largely spent in the air. There were two particularly common exercises, known as 'Erics' and 'Bullseyes'. 'Erics' involved day flights from one target area to another. 'Bullseyes' were operational night-time manoeuvres all over the UK, in the course of which there would be dummy bombing attacks on specified sites (London's bridges being particularly popular targets). Crews about to graduate were also given the task of 'nickeling' – dropping leaflets over Germany and occupied France

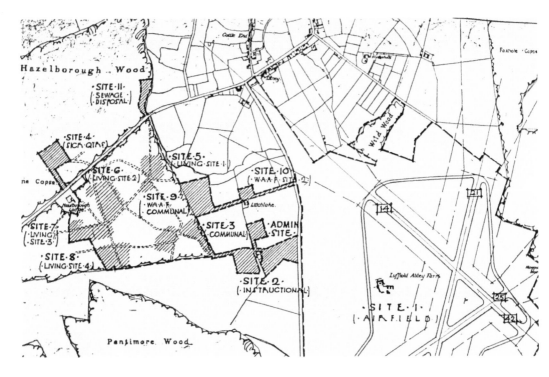

The Wartime Airfield

This detail from an old map shows the living accommodation and the airfield split by the Silverstone–Dadford road. The village is to the right of the T-junction. Below, close to the circuit, at the entrance to Site 2, a building that was originally the headquarters for the firm that built the airfield and later became the airfield's post office. In the early days of the track it served as a dormitory for marshals and other helpers.

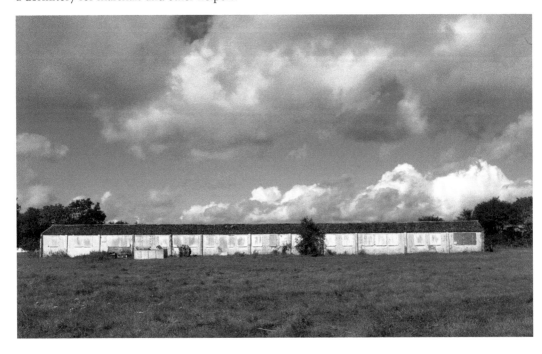

– and 'windows' – dropping metal strips over several European countries to confuse Nazi radar.

Training flights that involved low-level flying were particularly hazardous, and disorientation at night was common. No less than 124 Silverstone trainees were killed in just the first year of operation. Local residents could still remember some of these tragedies many years later. A Wellington was burnt out after a crash at Sootfield Green. Two collided over Whittlebury Park. 'I remember seeing a charred parachute in the rear gunner's seat at one of the wrecks,' recalled one young onlooker, 'and a mud-covered machine-gun and belts of ammunition lying around.' One Wellington, returning in the late evening, found another aircraft blocking the runway, skidded to avoid it, hit two trees and exploded; another, practising a night-time attack on a low-level target at nearby Leckhampstead (an old railway carriage painted white), crashed in a field.

The airfield was used with some regularity as an emergency landing ground for planes from other stations returning from operations. These could be tense occasions, the aircraft often being badly damaged or still carrying bombs. One unfortunate Halifax that crashed on such an emergency landing is today commemorated with a memorial behind the Luffield Grandstand. A local resident, Ron Roberts, recalls, 'We children cycled up to its remains. It had clipped a tree, just missed the hangar and crashed onto a field, right behind the guardroom. It was all in bits.'

From time to time, in an emergency, Bomber Command would call upon the trainee Silverstone crews. As early as August 1943, for example, Wellingtons from Silverstone took part in the successful destruction of the V2 base at the Forest of Éperlecques in the Pas de Calais. Similarly, just before the Allied invasion of Sicily, the Silverstone Wellingtons joined big night raids on Brittany, an operation designed to divert Nazi forces from southern Italy.

Keeping all the tired Wellingtons in a state of airworthiness could not have been easy. Each aircraft's engine and airframe would be inspected every day by its own ground crew. Refuelling could be hazardous. 'Walking along the wings to the fuel tanks, especially if it was frosty, was usually very dodgy,' remembered one Silverstone airman. And if a pilot strayed from the concrete surface in wet weather, the plane would usually have to be pulled out of the boggy ground by a tractor. Work inside the vast, unheated hangars could also have its problems, especially in winter, when metal could become so cold that it could even stick to the flesh and tear the skin away.

There was naturally a certain amount of mixing between the village and the base. Films shown at the airfield were a particular draw for the local children, one of whom still remembers the pleasure of seeing Joan Fontaine's *Jane Eyre* on three consecutive nights. Wartime concerts could include famous bands like the Joe Loss Orchestra. Off-duty servicemen would be drawn to the village. 'The air force were entertained on Sunday nights for those men that did not like going to the pubs,' recalled May Adams. 'We sang hymns and had coffee and biscuits afterwards.' The majority were probably content to do their singing in the White Horse, the Compasses, and the Royal Oak.

By the end of the war 8,600 airmen had been trained at Silverstone. 'The night peace was declared,' remembered May Adams, 'Silverstone became alive. The Air Force all came

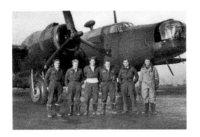 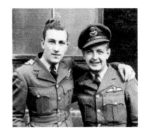

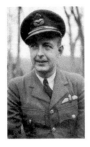 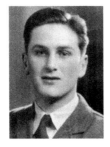 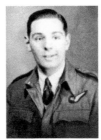

'They Will Not Grow Old...'

Clockwise from top left: A Wellington bomber at Silverstone in early 1944 with its newly formed Canadian crew; gunner Joe Mirault; gunner Bruce Somers with pilot Alvin Corless; flight engineer Ken Barnes, wireless operator Stan Bore; navigator raphael de Casagrande; pilot Alvin Corless. They died after being shot down over Belgium on a night flight to Germany. Below, historic Formula Fords at the end of the newly (and very aptly) named Wellington Straight.

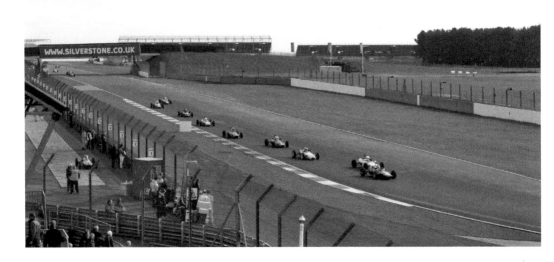

from the drome, marching down into the village streets in their pyjamas with overcoats on top, and their bands marching with them. They were cheering, shouting and singing. It was lovely to be alive to hear them. Later on we had street parties and dancing.' The RAF also celebrated peace with two open days. 'I remember two Lancasters there, as well as all the Wellingtons,' recalls John Pearson. 'Indeed, I was able to climb up a ladder to enter the belly of a Lancaster. Girls were packing parachutes in what was later known, because of its height, as "the elephant house". It was tall enough for chutes to be hung out to dry and inspected.'

The Immediate Aftermath: 1946–48

The airfield finally ceased to be operational in November 1946, and the Air Ministry soon hired out its hangars to Rootes, the Coventry-based car manufacturers, for the storage of Hillmans, Singers, Sunbeams and Humbers. But other, less official cars also appeared at the airfield from time to time. For example, a local Frazer Nash enthusiast, Maurice Geoghegan, invited some hill-climbing friends to an unofficial race on a 2-mile circuit he had created, running anticlockwise along the airfield perimeter, from Club to Stowe and Becketts, before returning down a runway to Club. The race, known in legend as 'the Mutton Grand Prix' because Geoghegan had the misfortune to make contact with a sheep, was later celebrated with a noisy session at the Saracen's Head, Towcester. News of the airfield's inviting open spaces inevitably spread, but it was still quite remarkable that Geoghegan's race was followed, only a year later, by an International Grand Prix.

The first act in this extraordinary drama of transformation occurred in 1947, when the thirty-six-year-old Smith Churchill and his wife Brenda took over Luffield Abbey Farm. Churchill worked for the Bucks 'War Ag', the important but not always popular Agricultural Executive, tasked by the Ministry of Food with getting the country's farmers to maximise the production of crops during the war, in order to counter desperate food shortages. In its bid to make every available acre of farmable land productive, the 'War Ag' offered advice, machinery and, if necessary, government instructions. Its work carried on in the early post-war years while food shortages persisted, Smith Churchill being asked by his Amersham head office to turn the Silverstone airfield (and those at neighbouring Turweston and Finmere) back into agricultural production.

He was an expert at the job. Trained in his native Norfolk in agricultural engineering, Churchill had worked before the war in his family business not far from King's Lynn, which hired out machinery to some of the biggest estates farming the Fens. For his Silverstone job, he had at his disposal the usual pool of tractors and heavy machinery together with a new workforce of displaced persons – Poles, Yugoslavians and Italians – from a camp near Shalstone. As usual in such situations, he began with some English lessons, and it was not long before Silverstone was echoing with various eccentric versions of his own Norfolk accent. 'Potato' was one of the first words learnt. That Smith Churchill had come to Silverstone to grow potatoes was something which amused the locals. How typical of a government which didn't understand farming! The hard clay would be useless for potatoes, and the airfield had lost all its top soil! Smith Churchill quietly kept his peace.

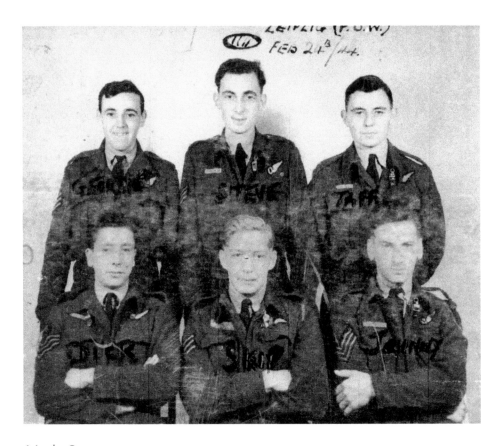

A Lucky Crew

An ageing photograph commemorates a Silverstone-trained crew (skippered by Flight Sergeant Tudor Jones) that beat the odds and got through the war unscathed. Below, the only one of the five RAF hangars still to survive. The area between the hangar and the Dadford Road was for many years after the war full of old RAF buildings, all the way up from Club to Woodcote (*see p. 19*). The last survivors eventually disappeared to make way for the asphalt car parks. These old buildings had made useful workshops for the racing fraternity: the premises of people like Eddie Jordan, Roger Dowson, Richard Lloyd, Derek McMahon and Robin Rew are still talked of fondly.

His first job was to make the farm itself habitable. After over a year of closure the whole airfield was in a state of deep neglect. Partridges and hares were everywhere. Security was another issue. The old runways were an attraction for the adventurous. Smith Churchill was sympathetic – he himself had been a successful speedway rider and grass-track racer in Norfolk and was currently employed in reviving his pre-war hobby of racing speedboats – but his job brought him into conflict with several groups of would-be racers. One such group, arriving optimistically with a number of 500cc single-seaters, was particularly vociferous when turned away by Churchill, but some good came out of the fracas, for the RAC, in hearing all about it, learnt of the airfield's excellent racetrack potential.

The RAC, in charge of British motor sport since 1897, and the British Racing Drivers' Club, formed in 1928, were two bodies particularly anxious to do something about the lack of racetracks in post-war Britain, now that Brooklands, Donington Park and Crystal Palace were not available. Various airfields had been mooted but Silverstone soon came to be seen as the very best option. The Air Ministry, however, was initially unhelpful, and Silverstone's future greatness might never have come about but for Francis Curzon, the 5th Earl Howe, the co-founder and president of the British Racing Drivers' Club. As a regular race winner before the war in his trusty Bugattis – he also won Le Mans in an Alfa Romeo – Howe was not someone who relished being beaten. A man of great influence, he duly pulled some strings and in late July 1948, *mirabile dictu*, the RAC acquired a one-year lease. Although it was not really part of the RAC's brief to finance racetracks, Howe had persuaded the membership that they should temporarily do so. A race was immediately scheduled to take place in three months' time, and not a minor one, to get things going gently, but a full-blown International Grand Prix. Not sanctioned by the FIA and therefore unable to hold the title of 'British', the RAC's Grand Prix of 1948 was a bold independent venture.

Colonel Stanley Barnes, who ran the RAC's competitions department, was given the job of securing a track manager for an initial three-month appointment. He selected a twenty-seven-year-old Scotsman, James Brown. Though Jimmy Brown was to prove an inspired choice, he must have seemed something of a risk at the time. He was, it was true, at home on an airfield, having been in the RAF during the war, based for much of it at Biggin Hill, engaged on reconnaissance work and the transportation of VIPs, piloting Blenheims, Spitfires, Hurricanes and Mosquitoes. He knew something of farms, too, for his father, a seed potato merchant and crop advisor from Airdrie, had often taken him on his travels. But he knew nothing of motor racing, and his limited work experience was hardly relevant. Before the war he had been in the costing and design departments of an Airdrie firm specialising in concrete, and at the time he was working for Tattersalls, the bloodstock auctioneers. But he was clearly up for a challenge and knew Silverstone village well. His wife Kay was the niece of the postmistress, and Brown himself had not only assisted behind the counter but also delivered the mail.

The highly competent Kay Brown quickly organised lodgings at Bleak Hall Farm, beside the airfield, and the Browns were soon descending on Luffield Abbey Farm to get the co-operation of the man from the Ministry. This would be crucial if the Grand Prix was to work. They need not have worried. So enthusiastic was Smith Churchill about the project

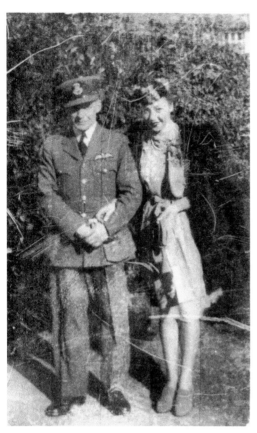

A Wartime Marriage

Time has not dealt kindly with the wedding photograph of Silverstone trainee Tudor Jones. In peacetime he was to spend many years close to the old airfield, working as a biology teacher at Preston Bissett. He was twice Mayor of Bicester. Reunited in old age with the pilot's seat of a Lancaster bomber in the RAF Museum, Hendon, Jones amazed everyone with his total recall of all the controls. Below, the still-surviving airfield control tower, close to the farm and overlooking the runways. It is now stripped of its rooftop platform and quite heavily disguised in its current role as a British Racing Drivers' Club washroom. It is hard to imagine that in 1948, at the circuit's first Grand Prix, the RAC used it as its Race Control building.

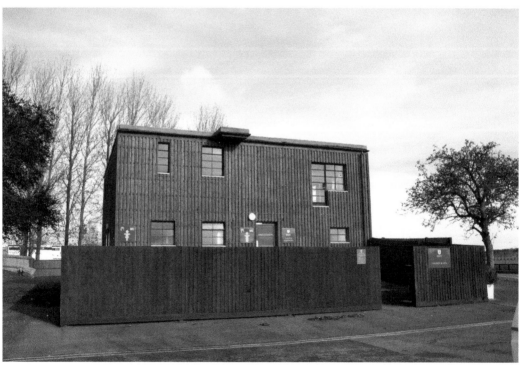

and so well did the two families get on with each other that there was an immediate pooling of their joint interests. The RAC's ambitions had suddenly become much more achievable.

The First Race, 1948

By the time of Brown's appointment the Grand Prix was only ten weeks away. The roads and runways were green with weeds. The cheap RAF buildings were rotten on the outside and filthy within. But local support proved staunch. One of the many helpers, May Adams, recalled: 'Mr Brown asked my sister and myself if we could go up to the aerodrome and clean out the nissen huts and officers' quarters. It was very dirty work. We had to knock all the loose plaster down so they could put a bit of paint on them. It took a few weeks. Then we had to wash the floors with disinfectant. I had to get some more women to help because in lots of the huts we had to make up beds for the car-park men – lots came down from London, some getting lodgings in the village. We did all sorts of work. We formed a line across and swept the runways. We stuck tickets (with numbers) on the improvised grandstands with a little bit of paste. Mrs Doris Bolman had to get about fifteen women to go on the toilet tents on the morning of the Grand Prix.' There was no mains drainage in those difficult early days.

Brown made his headquarters in the former guardroom, the first nissen hut inside the old main entrance, and it was from there that each day the Silverstone ladies would collect 'a chair, a bowl, soap, paper towels, disinfectant and, of course, our lunch box'. Silverstone resident Gerald Lovell remembers that many villagers helped out in the catering. 'There they were with their wrap-round aprons at trestle tables in the long tents, looking frightfully professional!' And there were 'armies of scaffolders who needed a room in the weeks before the race'. Lovell's father, a wood haulier, was enlisted to help with the advertising signs and fencing. Kay Brown herself had been helping with putting up advertising banners and the rope barriers, which were optimistically expected to restrain the crowd. It was all a glorious adventure.

The two races – one for the 500s at 12.00 and the sixty-five-lap Grand Prix in the afternoon – were organised by an RAC subcommittee. A good field was attracted, the RAC proudly advertising the appearance of 'many of Europe's most important motor-racing aces as well as Britain's own fastest drivers'. Farina, Ascari and Villoresi were among the foreign 'aces'. The British drivers were led by Raymond Mays and Reg Parnell. Much of the organisational responsibility fell to the Clerk of Course: 'It was certainly a mighty task,' noted *Motor Sport* afterwards, 'and Col. Barnes could be excused for getting somewhat harassed at times...'

The Churchills, living in the farm, were inevitably at the centre of things, with the start-line, grandstands and the apology for pits located nearby. So too was Race Control, housed in the aerodrome's control tower (where drinks and a cold buffet lunch were served to the RAC's most important guests). Several of the farm's barns were also hastily converted for use. 'Some of the official offices in the outbuildings of Luffield Abbey Farm,' commented *Motor Sport*, 'were a trifle Spartan.'

The circuit, 3.67 miles long, used two of the three runways (Copse–Stowe and Club–Maggots) as well as the parts of the perimeter road that connected Club to Copse and

Site 3 (Communal)

Archaeologists would surely have a wonderful time in the woods on the far side of the Dadford Road, exploring 17 OTU's living quarters. The old concrete roads, for example, of Site 3 (Communal) are still very much in evidence, as are foundations of many buildings (*see p. 6*). Below, the all-important generator house, which is also in the background of the picture above. A sergeants' shower-house was once among the trees to the left; to the right, the foundations of the gymnasium/chapel.

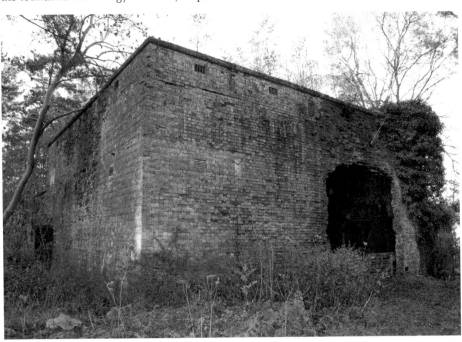

Maggots to Stowe (*see p. 18*). It was excitingly fast but flawed by the central meeting point, which cars approached from opposite directions, absolutely head-on, with only a screen and a few straw bales between them. These offending straights and corners were named after two fine (but ill-fated) pre-war drivers: Henry Segrave, the first British driver to win a Grand Prix, and Dick Seaman, the most recent. The allocation of names to all the corners injected some much-needed character into the venue. Most of the names referred to local places – Stowe House, Maggots Moor, Luffield Abbey and Chapel Green – though the RAC paid a tribute to itself with Club and Woodcote (the latter an allusion to Woodcote Park, its impressive Surrey clubhouse).

A last-minute panic was inevitable. Tents of every shape and size were hastily erected, bringing with them the air of an agricultural show. The temporary bridge by the start-line was only finalised just before the first practice day and the two small grandstands beyond it were still being worked on the day before the race. Smith Churchill's brother Bernard was summoned from the Norfolk Fens to help with the all-important straw bales – the sole protection for the spectators and the main means (together with 250 oil drums) of delineating the corners. In all, around 170 tons of straw bales were thought to have been used. Around 10 miles of telephone wiring had to be put in place, and 620 marshals had to be briefed. All too soon the big moment arrived.

Race day, 2 October 1948, dawned dry and sunny, helping attract vast crowds, perhaps even as many as 130,000. John Cobb, current holder of the world's land speed record, opened the circuit, waving politely as he toured round in a Healey Sportsmobile complete with motorbike escort. The start of the first race was less auspicious. Earl Howe, the starter, standing on a chair to get a good view and anxious, no doubt, not to have the day's programme running late, dropped the flag when the grid was still crowded with mechanics, some cars being topped with fuel, others awaiting their drivers. Howe also started the Grand Prix from the same trackside chair. All the drivers this time were ready for him. They raced from 2.00 p.m. to 5.00 p.m., fully justifying the adjective 'Grand', but even so there was no champagne for the eventual winner, Luigi Villoresi, who was happy enough with his bottle of lemonade. 'He was deaf after driving 250 miles at an average speed of 72.28 mph,' commented one report, 'and could only wave and grin to answer congratulations.'

The grin may not have lasted long. There was no drivers' washroom and such little crowd control that Villoresi and his Maserati teammate Ascari only escaped the thousands of admirers by driving their Lancia Aprilia across a potato field. Smith Churchill may not have been too pleased at this, but there were plenty of potatoes ready to be dug, all the way down to Abbey, and many of his recently threshed cornfields still boasted stacked sheaves. Gentle exhortations in early programmes were a testimony to his endeavours: 'Please avoid damage to valuable crops in and around the circuit.'

The organisers learnt a lot. The posse of sixty policemen was somewhat outnumbered, and the intended prize-giving in front of the grandstand had to be abandoned because of crowd invasion. It was, all in all, a good-hearted shambles, summed up by one telling press statement: 'The RAC has asked us to place on record their appreciation of those spectators

15

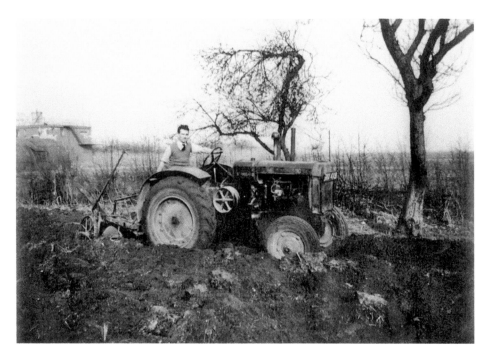

A Hands-On Approach

Smith Churchill and Jimmy Brown both revelled in the physical hard work needed to make the old aerodrome effective in its peacetime role. Above, Smith Churchill on a 'War Ag' tractor. Behind him (far left) is the airfield's control tower (*see p. 13*), still possessing the steps to the viewing platform. Below, Jimmy Brown at work with a diesel roller, July 1953. The hangar just past Copse is behind him. For most of the 1950s the farm was run by the Graham family. (Guy Griffiths Collection)

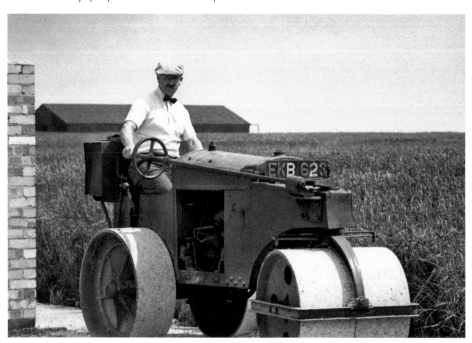

who got into the grounds without being asked to pay but who have since sportingly sent the money to the organisers.'

Suddenly it was time to clear up all the mess. May Adams recalled:

Mr Brown came round to my house to see if I could get some women to go up and clear the circuit. I said, 'When have we got to start?' He said, 'In the morning'. That was Monday! I laughed and said, 'I don't think I can get them at such short notice. How many women do you want?' He replied, 'twenty-two'. I went round that Sunday night and it was no trouble at all. They were all very keen to go. We were taken up on a lorry and we did have a good laugh.

Gerald Lovell remembers his mother doing 'paper-picking along with hundreds of others for the week after the big meeting; they were given sticks with a nail at the end with which they picked up litter all round the circuit.' Jimmy Brown was undeniably fairly brusque in his business affairs, but there was also an old-world courtesy about him that charmed the village. 'They all thought him ever so nice,' recalls Ron Roberts (who drove a breakdown truck at many meetings). 'He used to doff his hat when meeting ladies.'

Brown was to be employed at Silverstone, first by the RAC and afterwards by the BRDC, for the next forty years, living in a charming thatched house in the village before moving into Luffield Abbey Farm in the late 1950s, when his brief was extended to run both the farm and track. Smith Churchill, after finishing with the 'War Ag' in 1950, had moved out of the farm and into Winter Hills, a house just outside the circuit, where for many years he ran an engineering business and traded in second-hand motorbikes, cars and vans. The Churchills and Browns remained the closest of friends, sharing many holidays and, in particular, a passion for water-skiing. Jimmy was always keen to get Smith's views on the farm, Kay to act as passenger in Smith's competition speedboat. Both men extracted maximum fun from life. One typical story tells of them rushing off to Northampton, having spotted the advertisement of two Austin Sevens at bargain prices. They duly returned in great glee with their acquisitions, Jimmy Brown proudly emphasising that his car, unlike his friend's, had a sunroof, by circling triumphantly in front of Luffield Abbey Farm, his head and shoulders towering above the car. He was a big man for an Austin Seven. He was a big man in every way.

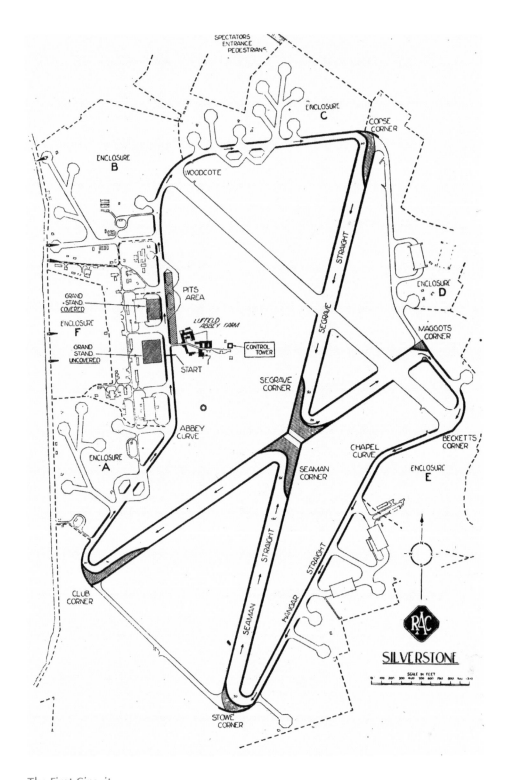

The First Circuit
The old aircraft parking bays, leading off from the perimeter road, are clearly visible on the circuit plan for the RAC Grand Prix, October 1948.

Silverstone's Story

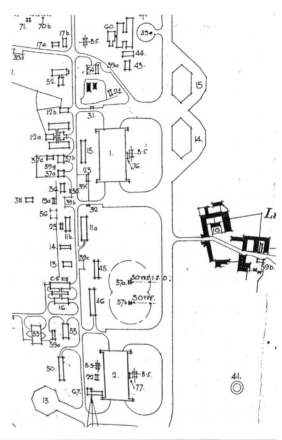

The First Start-Line

This detail from a plan of the old airfield shows some of the many buildings which were once situated between the Dadford Road and the runways. Two of the airfield's five hangars (marked 1 and 2) can be seen; Luffield Abbey Farm (marked 10 and 59b) is to their right, separated from the huddle of RAF buildings by a small section of the perimeter road. This straight part of the perimeter road (between Abbey and Woodcote) was where the start-line, pits and grandstands were situated for the circuit's first four years. The photograph below gives this important area's approximate position, with the hangar to the left and the farm to the right (hidden behind a bright metal screen). The track that leads to the bridge (no longer in use) must be close to where the old perimeter road used to run.

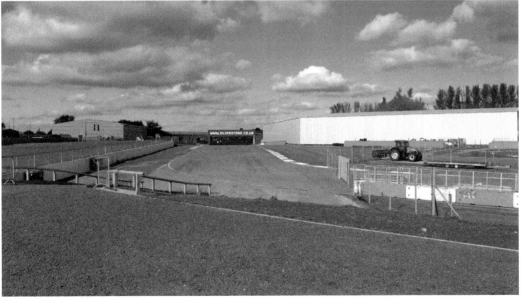

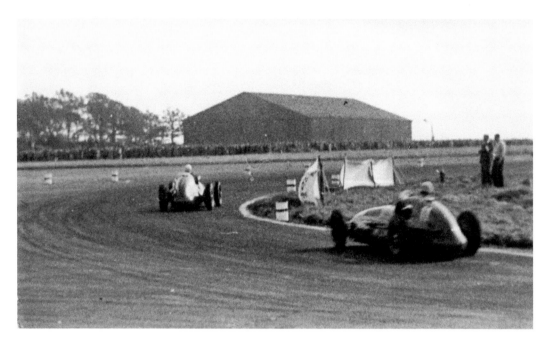

The First Winners

Two of the latest flame-red Maseratis (4CLTs) dominated Silverstone's first race, the RAC Grand Prix of October 1948. Above, Luigi Villoresi leads Alberto Ascari. They are seen entering Copse, a particularly tight right-hander in 1948, for instead of following the perimeter road (where spectators stand in front a hangar) competitors drove down the first half of the Copse–Stowe runway. Below, the runway up which the competitors of 1948 would have been coming.

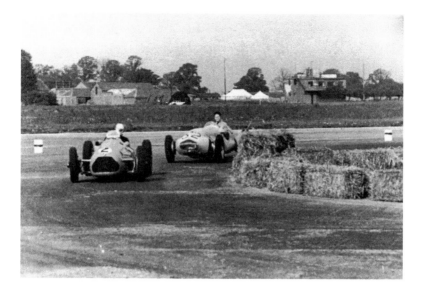

The Farm and the Circuit, 1948

Franco Comotti (Talbot) and Paul Emery (Emeryson) at Segrave corner in practice. Behind them, Luffield Abbey Farm (*below*) and the RAF control tower. Behind these, but out of sight, is the Abbey–Woodcote Straight. Emery, a notable builder of 'specials', had sold this attractively bodied car of his to Irishman Bobby Baird, whom he was helping out at the meeting as reserve driver. Though its straight-eight 4½-litre Clemons engine had once graced pre-war Brooklands, the Emeryson failed to qualify.

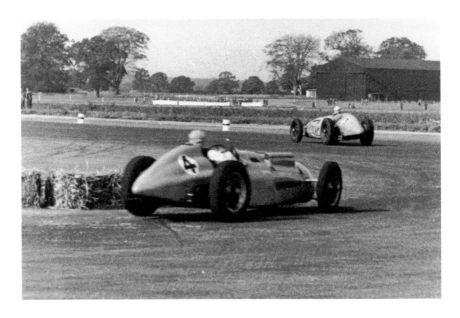

Talbots at Seaman Corner, 1948

Philippe Étancelin and Louis Rosier turn from one runway (Stowe–Copse) to another (Maggots–Club) at a corner created by hay bales in the centre of the old airfield. White advertising hoardings behind them mark Abbey Curve. The hangar (number 2, *p. 19*) was situated just before the start-line. Below, part of a self-contained inner circuit used for single-seater instruction. The grassy apex where the two straights intersect must be close to the site of Seaman Corner.

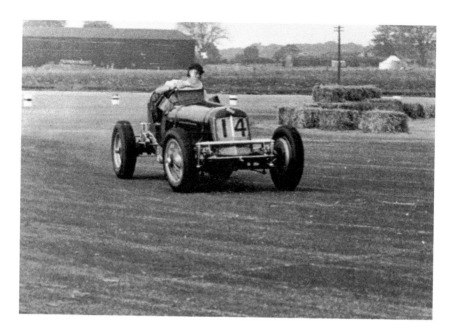

ERA at Segrave

Rushing up from Copse, future Le Mans winner Peter Walker rounds Segrave in an ERA (belonging to his friend Peter Whitehead) and turns onto the runway leading to Maggots. Hangar 2 is in the background. To its right, in the far distance, a few RAF nissen huts lurk darkly. Below, the site of Segrave Corner, overlooked by the stands at Farm Curve, a fresh part of the recently modified Grand Prix track.

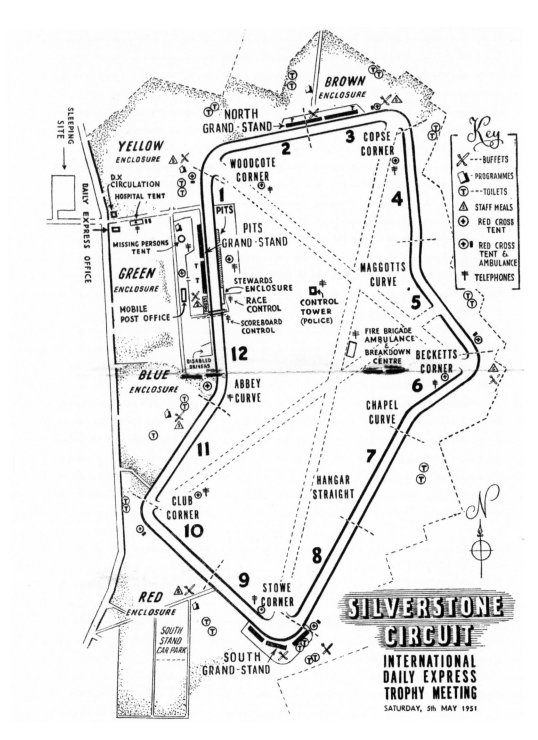

The New Perimeter Track, Post-1948
From a 1951 race programme.

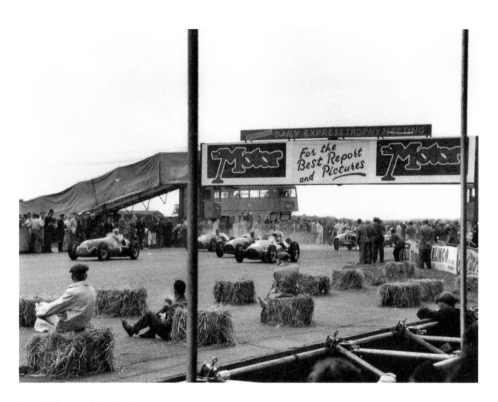

Hay Bales and Optimism, 1950

Above, the start of an International Trophy heat. All those present would have lived through the dangers of a world war, so what were a few racing cars to worry about? The timekeepers look safe enough in their doubledecker, as Fangio (left, in an Alfa Romeo) and Giraud-Cabantous (right, Talbot) get away from Ascari (Thinwall Special) and Claes (Talbot). Below, a somewhat more professional atmosphere as a Peugeot in the 6 Hours of Silverstone race passes the current Grand Prix starting grid. (Top photograph: Ferret Fotographics)

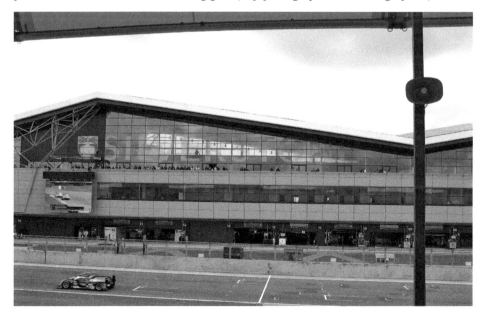

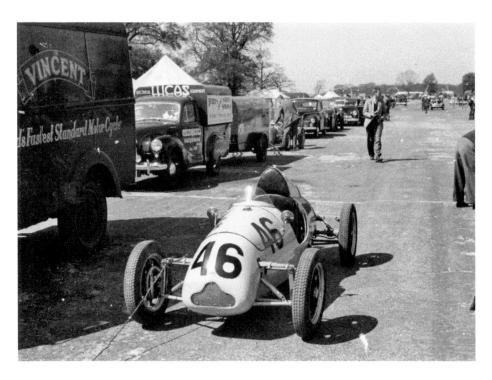

The Main Entrance, 1950

Above, a 500cc Cooper, raced by Austen May, is towed into the circuit. The trees in the distance, beyond the Dadford Road, are some of those that helped camouflage the RAF's wartime 'village'. Above the roof of the first parked saloon car the old RAF guardroom can just be seen. It served as the BRDC's office for many years. Its successor is to the left in the photograph below. To the right, the striking Silverstone Innovation Centre. (Top photograph: Simon Lewis Transport Books).

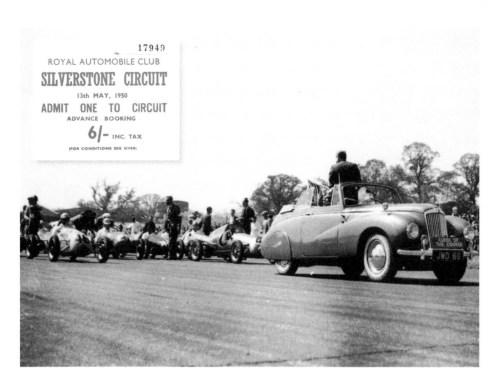

Clerk of the Course, 1950

May's (ex-Stirling Moss) Cooper stands on the front row as the supremo of the RAC's Competitions Department, Colonel F. Stanley Barnes, prepares to lead the rolling start in his Sunbeam Talbot 90. It was Barnes who had the good sense to hire Jimmy Brown as track manager. Hangar 2 is just visible to the left. Below, the old start-line, where Colonel Barnes' Sunbeam was parked so imperiously, would have been just beyond the bridge. See p. 19 for reverse view.

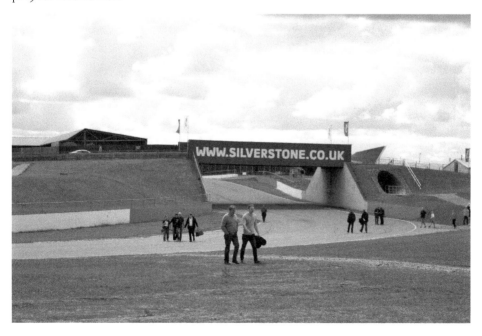

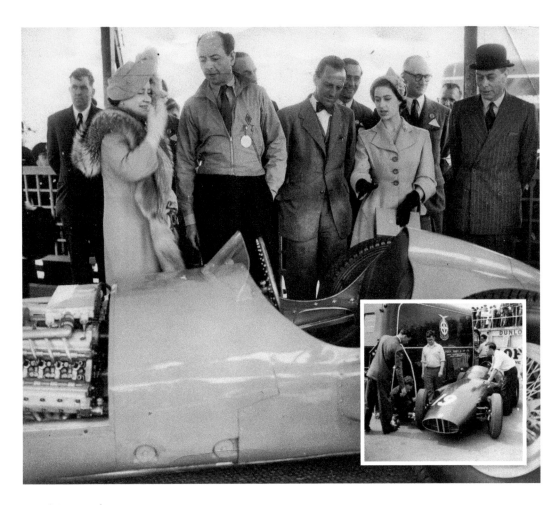

Royal Approval

Silverstone's popularity was immediate. From as early as 1949 there was a second annual Formula 1 race, the *Daily Express* International Trophy, Jimmy Brown having arranged this important sponsorship deal via the *Express*'s motoring correspondent, Basil Cardew. Club meetings also proliferated, and Silverstone's swift rise to national prominence was exemplified by the visit of the King George VI and Queen Elizabeth to the Grand Prix of 1950. In addition to spectating from a specially decorated stand on the Abbey–Woodcote finishing straight (the scaffolding ameliorated by bunting and flowers), the royal party also watched from a somewhat basic raised platform at Stowe. In the course of the visit they were introduced to Raymond Mays and the new Grand Prix car shortly to be launched by Mays' British Racing Motors (*main picture*). Far from ready, it was nonetheless given three demonstration laps by Mays. Hopes were high. 'The BRM car which you will see demonstrated for the first time on this circuit,' wrote Mays in the programme, 'represents a courageous venture at a difficult period in our industrial history ... This is the forerunner of a team of British Grand Prix cars, the success of which, we believe, can be of incalculable benefit to a nation dependent as we are on our prestige in the markets of the world ...' A few months later, alas, the BRM ignominiously failed to start at the International Trophy meeting.

Inset, eight years on, another BRM at Silverstone. The team had still not won a Grand Prix, and Jean Behra's P25, seen in the paddock with engineer Tony Rudd (centre) was not destined to do so in this race, but Behra won the 1957 International Trophy and in 1959 Jo Bonnier would bring BRM its first Grand Prix success.

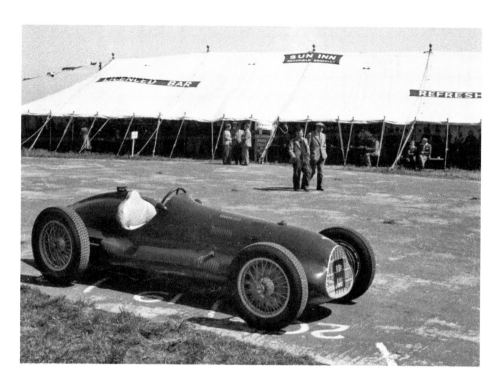

Need for Refreshment

Another photograph from the Grand Prix of 1950, above. Leslie Johnson's E-type ERA is to the fore, but unfortunately this rare and once very promising machine, first seen in 1939, only lasted two laps in the race before its supercharger exploded. The modern paddock café (*below*) may lack the garden party atmosphere of the refreshment marquee above, run by a local pub (the Sun at Whitfield), but its looks have been improved by the current bold projection of a corporate image. (Top photograph: Simon Lewis Transport Books)

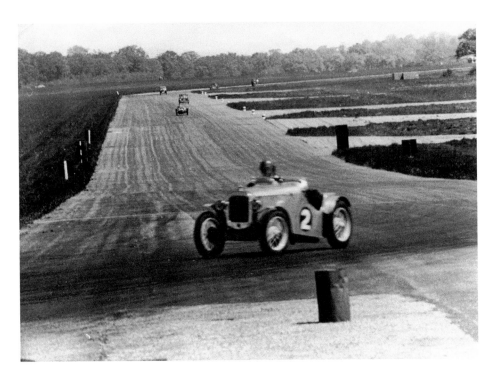

Into Stowe

The Hangar Straight, the old airfield's wide perimeter road, looks distinctly rustic in 1951 as A. R. Morton (2) leads his fellow 750cc Austin Sevens in a five-lap race in 1951. Two hangars and three aircraft parking bays (*see p. 18*) are just out of the right-hand side of the picture. Below, the headquarters of the Silverstone Experience Centre can be seen to the left of the bridge in what is now a highly developed infield. (Top photograph: Guy Griffiths Collection)

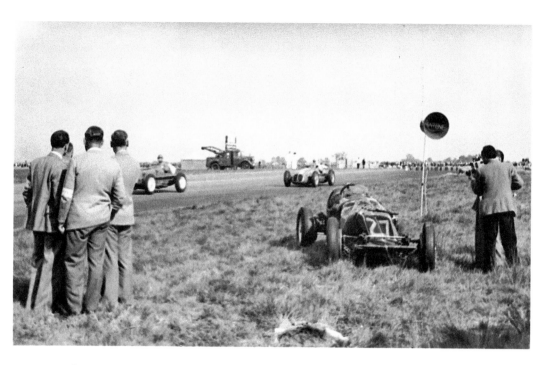

Out of Stowe

Above, a wrecked ERA that had overturned on the exit from Stowe in 1949, throwing out and hospitalising its driver, John Bolster. The very same ERA, repaired and given an extra supercharger, crashed at the same corner in the International Trophy a few months later. Its driver, St John Horsfall, a former stockbroker and an MI5 spy during the war, was killed, becoming the circuit's first fatality. Below, today's corner has moved inwards, the earlier track now lying under the seating and terracing.

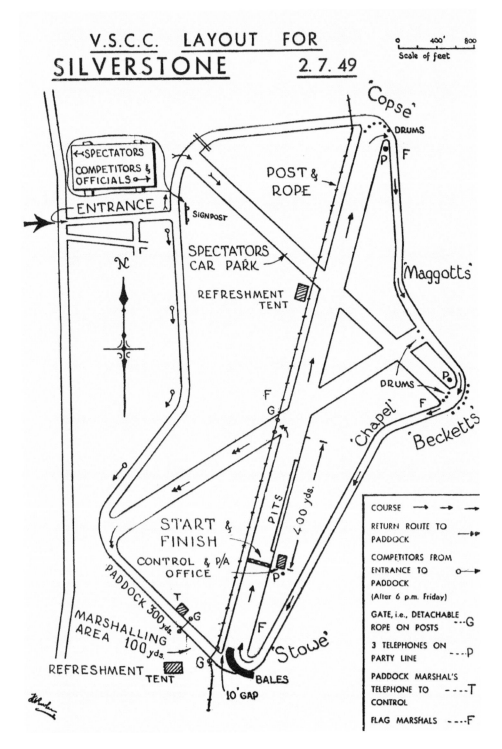

V.S.C.C. LAYOUT FOR SILVERSTONE 2.7.49

Scale of feet
0 400' 800

'Copse'

DRUMS
F
P

POST & ROPE

SPECTATORS
COMPETITORS &
OFFICIALS

ENTRANCE

SIGNPOST

SPECTATORS CAR PARK

REFRESHMENT TENT

'Maggotts'

N

DRUMS
P
F

'Chapel' 'Becketts'

F
G

400 yds.

PITS

START & FINISH

CONTROL & P/A OFFICE
P

COURSE → → →

RETURN ROUTE TO PADDOCK

COMPETITORS FROM ENTRANCE TO PADDOCK
(After 6 p.m. Friday)

GATE, i.e., DETACHABLE ROPE ON POSTS ---G

3 TELEPHONES ON PARTY LINE ---P

PADDOCK MARSHAL'S TELEPHONE TO CONTROL ----T

FLAG MARSHALS ----F

PADDOCK 300 yds.
MARSHALLING AREA 100 yds.

T G

REFRESHMENT TENT

F

'Stowe'

G BALES
10' GAP

An Early Shortened Circuit
Only one side of the track, utilising the Stowe–Copse runway, is in action.

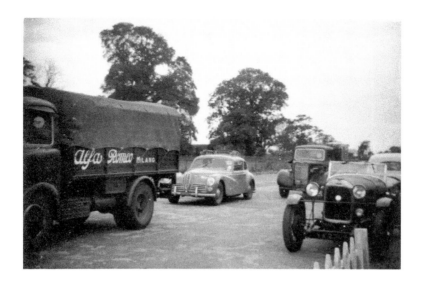

All the Way from Milan

This canvas-backed Alfa Romeo transporter, arriving for the British Grand Prix of 1951, would have sent many an enthusiast's pulse racing. It is followed into the circuit by a glorious Freccia d'Oro (Golden Arrow) Alfa Romeo 6C 2500, the first Alfa to be built after the war, and one that did much to restore the company's fortunes. Each works driver, apparently, was given one. Below, much grander transportation is required in the modern era, not just for Grand Prix cars but also saloons.

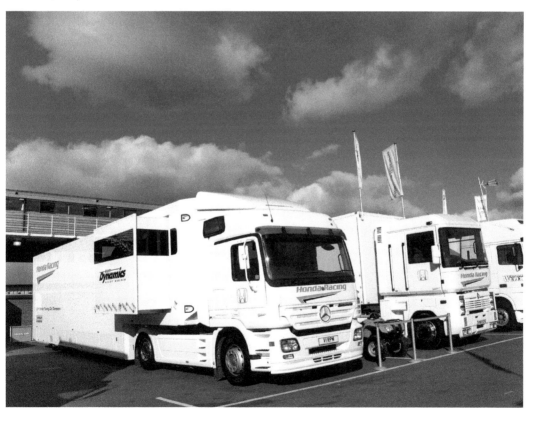

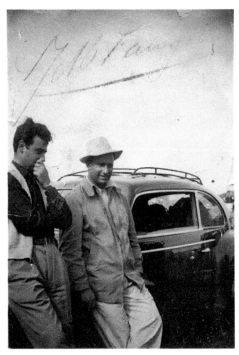

South American Celebrity

A much-handled photograph, signed by one of the greatest drivers of all time, Juan Manuel Fangio (seen above in the hat) – a rare relic of the Grand Prix of 1951. That year, Fangio, driving one of the Alfa Romeos, won the first of his five world titles, though in this particular race he had eventually to give best to the Ferrari of his fellow Argentinian, José Froilan Gonzalez. The forty-year-old Fangio is shown here in the Silverstone paddock with another Argentinian driver, Onofre Marimon, whose father had raced with Fangio in South America and who had just arrived in Europe, looking for drives. Below, two later South American F1 stars, Argentinian Carlos Reutemann and Brazilian Carlos Pace, seen at Silverstone in 1975.

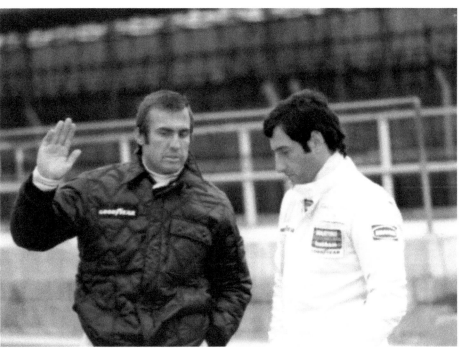

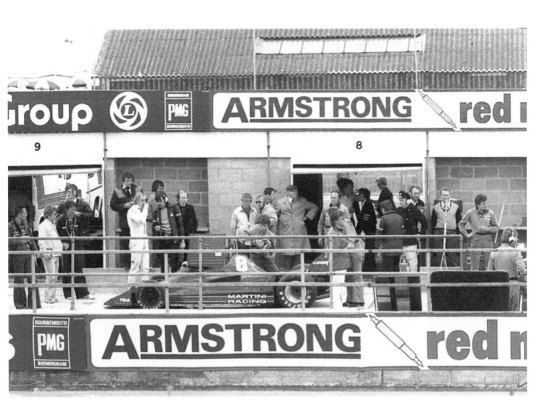

Italian Glamour

Right, an Alfa Romeo 159 in the Silverstone pits, 1951. There were no garages for the cars – the pits were created from market stalls, scaffolding and canvas – but there was a smart little box high up for the race commentators. Above, Silverstone's first pit-garages (of 1974), used by Bernie Ecclestone's Brabham-Alfa Romeo team in the 1977 Grand Prix. Hans Stuck talks to designer Gordon Murray. The roof of the long-serving scrutineering bay looms behind.

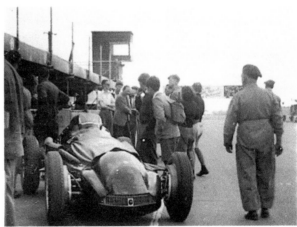

Drivers of Different Eras I
Alfa Romeo's Giuseppe Farina, not looking his usual morose self, relaxes amid the scaffolding of the Silverstone pits at the 1951 GP. Farina was world champion in 1950 (when the FIA championship for drivers began), having won at Silverstone, Bremgarten and Monza, and now, in 1951 at the age of forty-four, he had already been victorious at Spa. He was, however, to retire at Silverstone. The last year that the pits and start-line were situated near Luffield Abbey Farm on the Abbey–Woodcote Straight was 1951. From 1952 to 2010 all races would start at the exit of Woodcote.

Below, another Italian driver, but of a different temperament: Lotus's Alessandro Zanardi, amid the better facilities at the 1993 Grand Prix. Zanardi's Grand Prix career was not a spectacular one – exemplifying the need to be driving the right car at the right time – but he was a great success in Indycar racing before a shocking accident ended his career. His gold medals in the London Paralympics won him worldwide admiration.

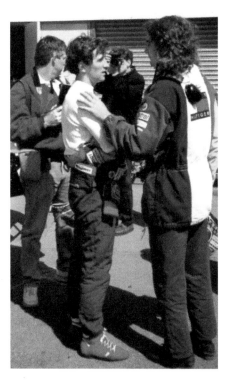

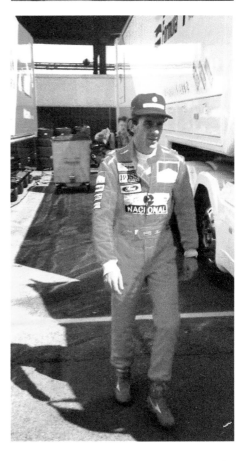

Drivers of Different Eras II

Consalvo Sanesi, a teammate of Farina and Fangio, seen here at the back of the Alfa Romeo pits during the 1951 Grand Prix. The snapshot gives an excellent idea of the narrowness of the pits of this early era. Not only were there no garages, there really was no paddock; Jimmy Brown had to negotiate with the Air Ministry's tenant farmer over the use of a field close by. Sanesi was for many years Alfa Romeo's leading test driver, but his best results in Grand Prix Alfas were in the immediate post-war years, before the World Championship was inaugurated.

Below, a driver with rather more success, Ayrton Senna, seen behind the pits on the way back to his motor-home, shortly after practice for the 1993 Grand Prix which would turn out to be his last race at Silverstone. It was not his luckiest of circuits. Of Senna's nine British Grand Prix starts at Silverstone he secured one pole position (1989) and one victory (1988).

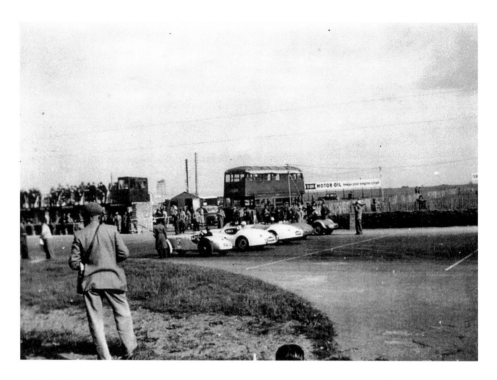

A Fresh Start

A club meeting in 1952, the year the British Racing Drivers' Club marked their taking over of the circuit's lease from the RAC by moving the start-line to the Woodcote exit and building some narrow brick pits along the straight. Money was scarce, so both the timekeepers' double-decker bus and the commentators' hut were reused at the new site. Below, Modern Formula 3s in front of the Woodcote hospitality suites. The leading car has just passed where the start-line was originally sited.

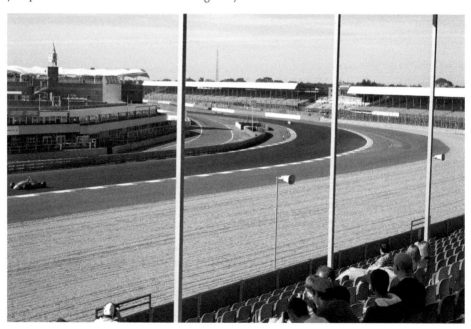

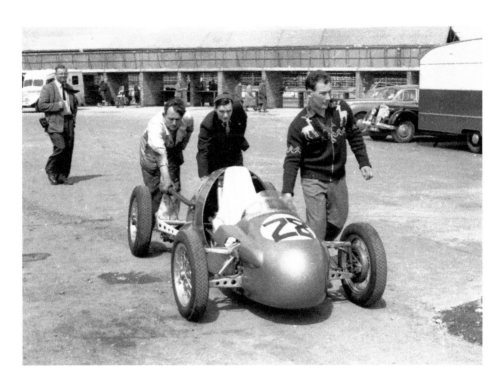

Brave New World

Stirling Moss, in a smart woolly jumper, helps push his 500cc Kieft-Norton in the spacious new paddock of 1952. A week after this *Daily Express* Trophy meeting his Kieft would be severely damaged in a crash, but young drivers like Moss and indeed young circuits like Silverstone were British motor racing's brave new world. Below, a Formula Renault is pushed through the paddock to the race assembly area for a modern young hopeful. (Top photograph: Simon Lewis Transport Books; bottom photograph: Henry Chart).

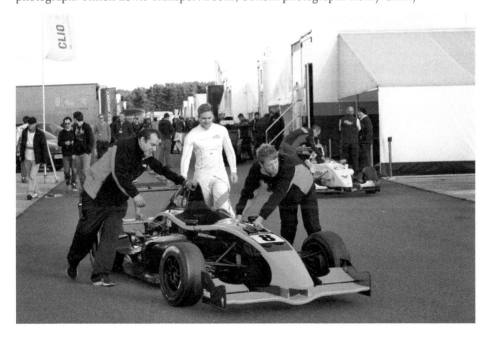

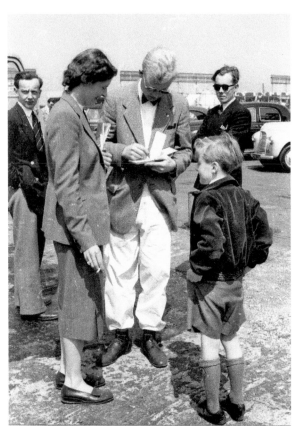

Paddock Duties

One of the charms for spectators in the early days was the easy accessibility of cars and drivers, even at Grand Prix level. They simply paid a little extra for a paddock pass. Above, Mike Hawthorn obliges with an autograph at the 1953 International Trophy; a meeting in which Hawthorn, in his first season with Ferrari, won both the F1 and the sports car races. He is wearing the bow tie with which he regularly raced. The tweedy sports jacket over his overalls would surely go down admirably in a Goodwood Revival meeting. Below, the two works Honda drivers in the British Touring Car Championship: three-time championship winner Matt Neal and 2012 series winner Gordon Shedden, participating in one of the popular official autograph sessions in the paddock area. (Top photograph: Simon Lewis Transport Books)

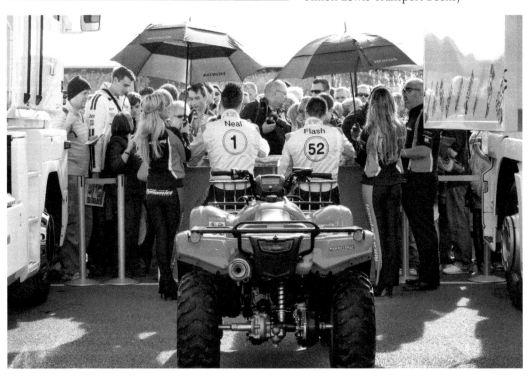

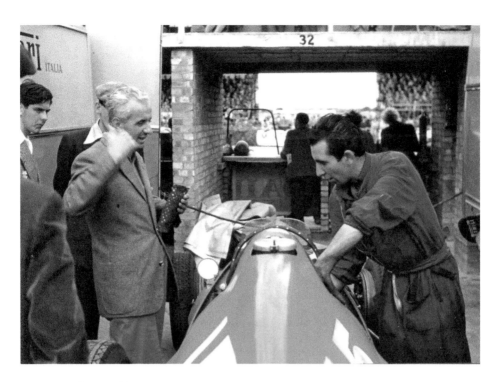

Keeping Tabs on Things

Luigi Villoresi, the 1948 RAC Grand Prix winner, encouraging his works Ferrari mechanic at the back of the pits before the start of the Formula Libre race in the Grand Prix meeting of 1953. Below, keeping tabs on a car's performance has become a more precise art in the computer age as Jacques Villeneuve and his BAR team suggest, photographed on the pit wall during a F1 testing day in 1999 with laptops at the ready. (Top photograph: Simon Lewis Transport Books)

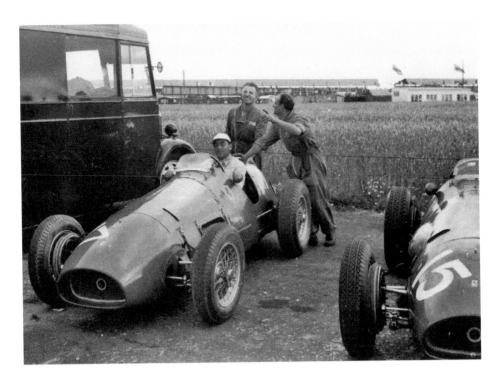

Challenging Conditions I

The F1 season of 1952 was run under F2 rules – hence the addition of Formula Libre races for cars with larger engines – and Ferrari brought three of their all-conquering 2-litre cars to the Grand Prix. The Ferrari mechanics, however, had to look after these important cars in less-than-ideal conditions, separated from the pits by a field of flourishing corn. Below, a Le Mans Toyota being attended to in Silverstone's wonderful new complex, the Wing. (Top photograph: Simon Lewis Transport Books)

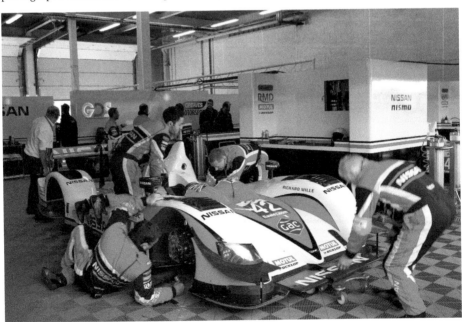

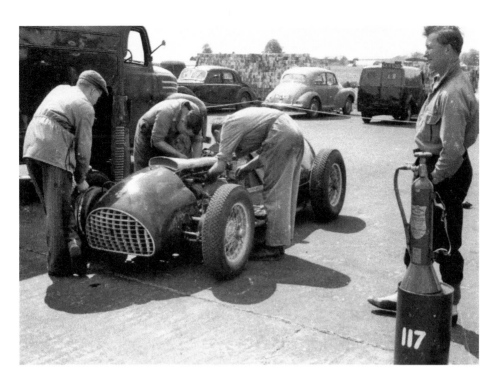

Challenging Conditions II

Peter Whitehead watches as his mechanics work in the open on his private Ferrari, entered for the 1952 Grand Prix. Whitehead, a farmer who would have felt at home at Silverstone, did a lap of honour at that meeting in the C-type Jaguar in which he and (fellow farmer) Peter Walker had won Le Mans the previous year. Below, another modern contrast: a Zytek Nissan being worked on at the Wing before the 6 Hours of Silverstone race. (Top photograph: Simon Lewis Transport Books)

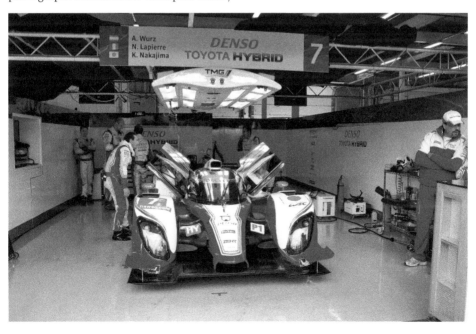

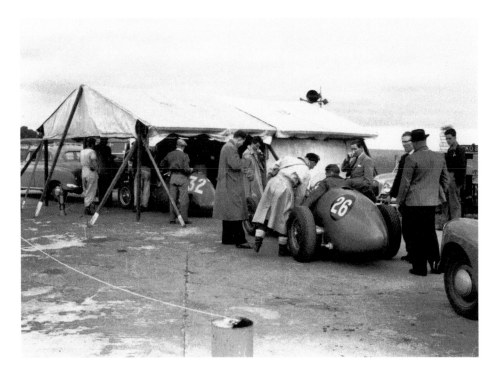

A Less Than Serious Sport I

A tent on the Club Straight served for scrutineering at the 1952 Grand Prix, a token of the pervading amateurish atmosphere. Gallant attempts to be more professional shed light on a prevailing public disinclination to take the sport too seriously. 'The earth bank around this circuit,' commented a programme of the period, 'has been erected as a crash barrier for your protection. It is forbidden to stand, sit or climb on it'. Below, Formula Fords at the current, more adequate scrutineering bay (built in 1995).

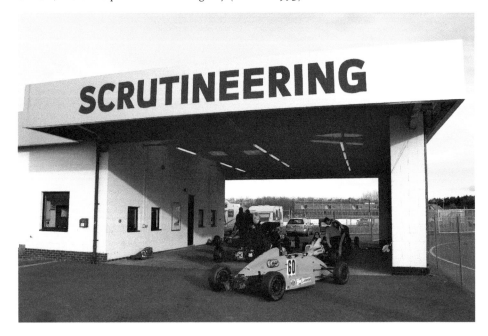

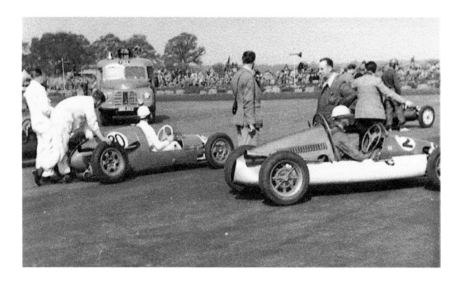

A Less Than Serious Sport II

A group of 500s assembles at the end of the Club Straight. 'Pop' Lewis-Evans (2) was a lone advocate of seat belts and roll-over bars. Bill Grose (20), whose Northampton garage supplied the circuit with breakdown trucks, follows the prevailing preference (even at Grand Prix level) for no such safety measures. Below, three Grand Prix drivers, Bucci, Villoresi and Marimon (left to right), cross the bottom of the Club Straight *en route* to the pits in 1954. Poor Marimon was to die at the Nurburgring a week later.

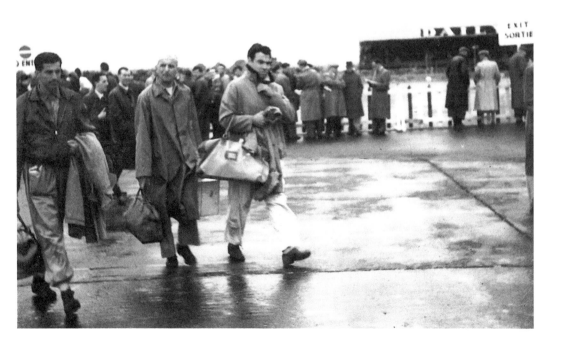

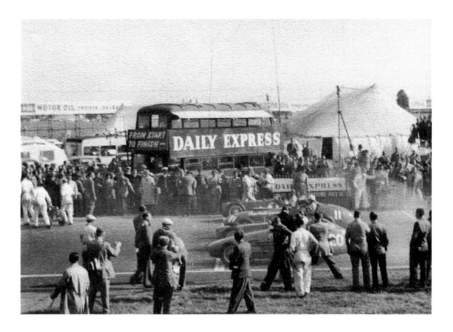

On the Grid, 1953

The Formula Libre race at the Grand Prix meeting. The eventual winner, Farina, in Vandervell's Thin Wall Special (11) beside Fangio (3) and Hawthorn (20). The *Daily Express* was now underwriting the big meetings and giving the profits, if any, to the BRDC. Below, James Hunt (McLaren) and John Watson (Brabham) on the front row of the 1977 Grand Prix. Those watching in the BRDC enclosure have a fine view but limited protection. McLaren's Teddy Mayer is alongside Hunt.

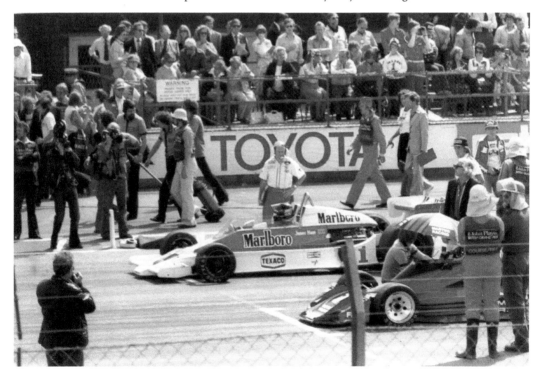

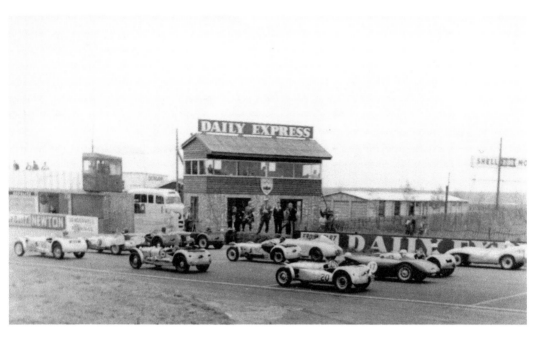

The Charge to Copse

A rare photograph showing the start of a club race in 1956 and the splendid new timekeepers' box (which demoted the double-decker bus to lesser duties). Some casual officials disport themselves on hay bales beneath it. The single-storey Race Control building is to its right. Extreme right, the almost empty Stewards' Enclosure. Below, a modern start, behind a pace car, with all the officials and spectators firmly out of harm's way. (Top photograph: Simon Lewis Transport Books)

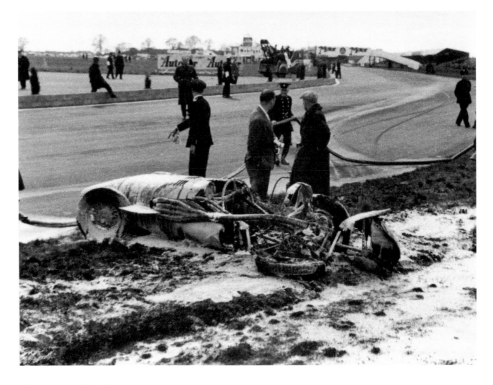

The Demands of Copse

A spectator's photograph of the remains of Ken Wharton's Vanwall after a crash at Copse in the International Trophy of 1955. The grass bank had done its job, and Wharton, fortunately thrown out, escaped with minor burns. Corners were now being delineated with low breeze-block walls with small conifers behind, rather than oil drums filled with sand. Modern spectators at Copse, though safer, are some distance from the action. Across the track, to the right of the scrutineering bay, the impressive modern pit-garages.

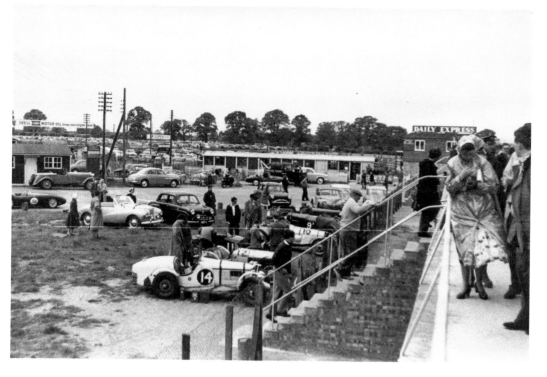

The Grassy Paddock

A delightfully relaxed atmosphere in the paddock during an 8 Club meeting, 1956. The hut to the left is the Steward's Room. The long single-storey building is Race Control, also headquarters for the telephones and loudspeaker system. Far right, the back of the timing box. Below, a quiet test day scene in 1974, with a Connaught getting a push. The grass has given way to tarmac, and the inadequate brick pits are about to be pulled down.

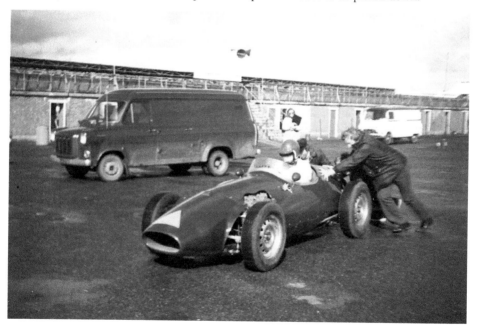

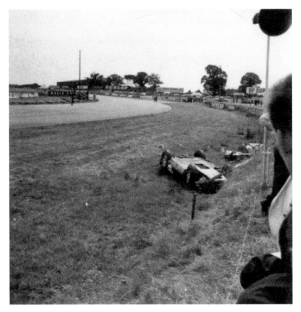

Vintage Woodcote

Masten Gregory somehow managed to bail out of his Lister-Jaguar just before it came to grief at Woodcote in 1958 – a reminder of how challenging a corner this was after the flat-out blast from Abbey. A chicane was installed in 1975, and then a series of slow bends (1991), today's version of which the Formula Fords (*below*) are seen negotiating. The one surviving hangar is visible in both photographs, but the RAF's water tower, still extant in 1958, was pulled down in 1995.

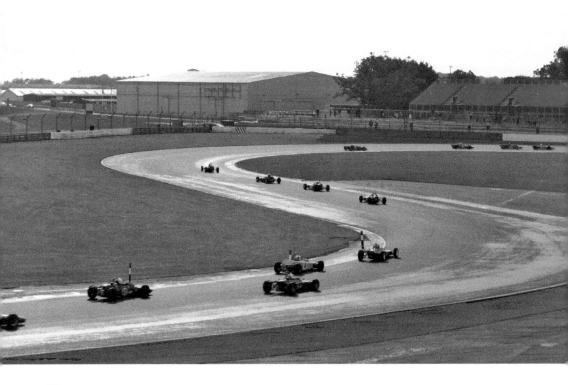

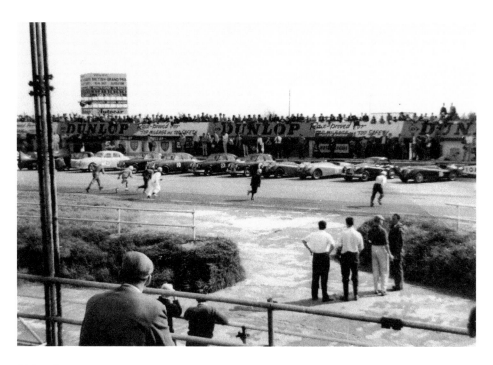

Risk-Takers

Spectators on the walkway above the pits enjoyed a wonderful view, as seen here at a Le Mans start in 1960. Those watching from ground level, however, had no protection from spinning cars, and a double fatality in 1963 provoked the building of an elevated pit-lane. Below, as James Hunt and John Watson head off from the front row in 1977, various onlookers seem bravely oblivious of their hazardous situations. The start had been moved 100 yards further from Woodcote in 1975.

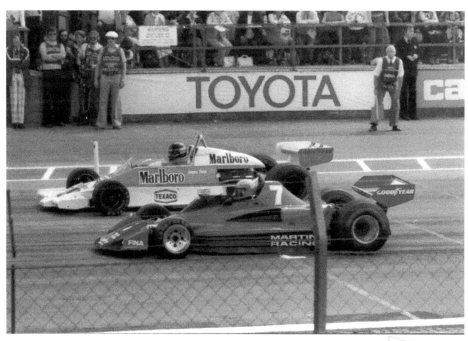

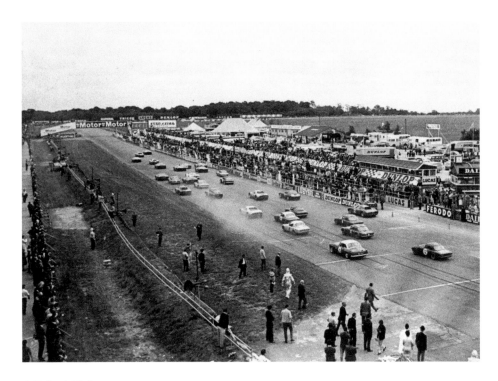

A Raised Pit-Lane

GTs head to Copse in 1967. The elevated pit-lane of 1964, approached by a gentle ramp, was an important advance, but the pits themselves (still not extending beyond the bridge) remained as poor as ever. Towards the back of the paddock can be seen (left to right) the refreshment tent, the single-storey café and the scrutineering bay. On the outside of the track are still traces of the tarmac of the aeroplane parking bays, now well submerged (*below*) under the gravel traps.

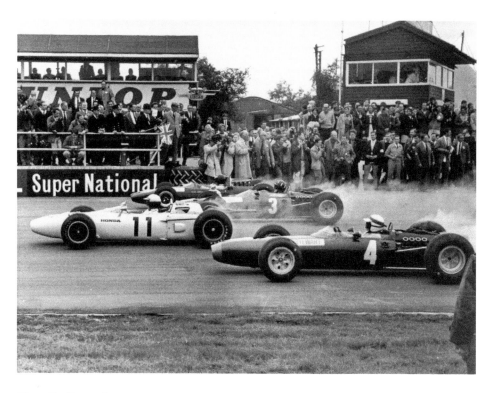

Close Excitement

Jackie Stewart (BRM, 4), Richie Ginther (Honda, 11), Graham Hill (BRM, 3) and Jim Clark (Lotus) head off at the drop of a Union Jack (British Grand Prix, 1965). The small press box became 'the doghouse', headquarters for a band of enterprising drivers' wives and girlfriends, who over the years have raised big sums for motor racing charities. Below, GTs await their less frantic departure behind a pace car, before a distinctly more professional backdrop.

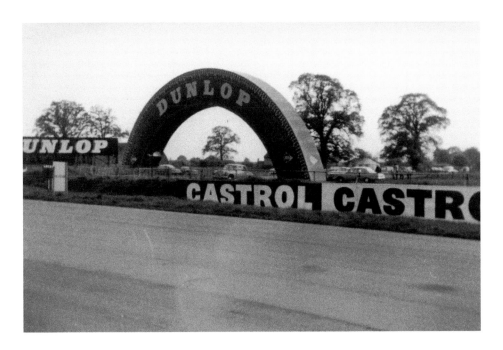

Dunlop's Dramatic Greeting

Dunlop's footbridge, in the shape of half a tyre, had been an important feature at Le Mans, straddling the racetrack since 1950. Silverstone's Dunlop Bridge, which copied it, was close to the track but didn't straddle it. Nor was it a footbridge. So, until the *Daily Express* Bridge (*see p. 71*) was built in 1968, both traffic and pedestrians *en route* for the paddock and needing to cross the track between Abbey and Woodcote could only do so between races. Below, a modern welcoming arch.

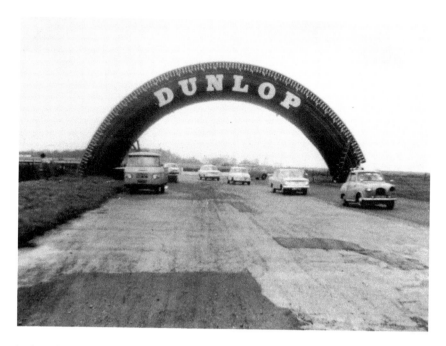

Dunlop's Splendid Farewell

Erected in 1965 over the main entrance (*see p.26*), the Dunlop Bridge gave a welcome touch of drama to the flat old airfield, which was much missed when it gave second best to the weather in the mid-1970s. It was not only a reminder of important help received from parts of British industry but also a bold statement of intent by the BRDC. Below, Silverstone's Innovation Centre (partly visible beyond the farewell arch) exemplifies the ambitious diversification programme of recent years.

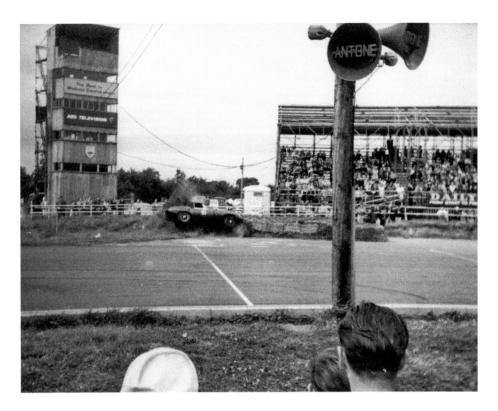

Sixties Atmosphere I

Martin Lilley's E-type Jaguar gets Woodcote all wrong at a club meeting in 1964 under the gaze of the radio and television tower, advertising its partnership with ABC Television ('the best in weekend entertainment'). Access was by a series of stepladders. The bright kiosk to its right sold Flowers beer. The ubiquitous wires of Anthony Curtis's 'Antone' loudspeaker system enveloped Silverstone determinedly. Below, the start of a supporting saloon car race at a big event soon after the creation of the raised pit-lane in 1964.

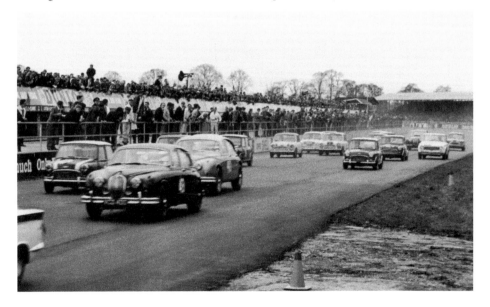

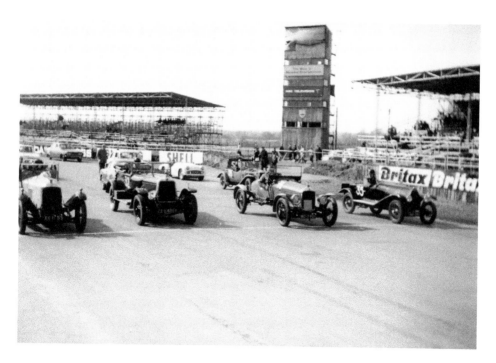

Sixties Atmosphere II

Club events continued to proliferate, the Vintage Sports Car Club being one of the keenest organising bodies. Above, the grid for a VSCC Pomeroy Trial, a speed test based on handicaps. Laurence Pomeroy, who died in 1966, had been a distinguished motoring writer as well as the club president. Below, behind the speeding bikes, is the new Dunlop Tower, erected (for television, radio and press) in 1967. For many years an iconic feature, it was taken down in 2003.

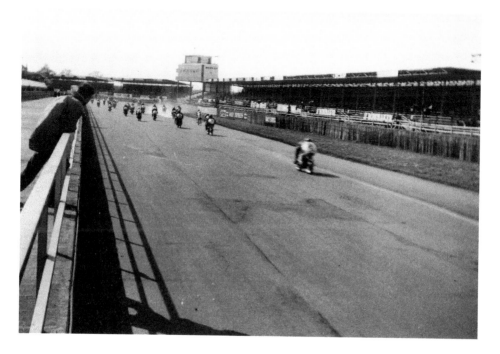

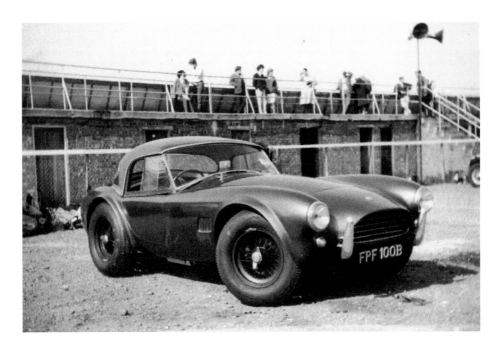

Dwarfed by Machinery

The arrival of the raised pit-lane had done little for the pits themselves, though a new wire fence (visible behind the AC Cobra) gave the teams a little privacy. Below, the current, more adequate pits, which, though steadily upgraded, still date back to the 1980s and can look a little dwarfed by big transporters. The old Club Circuit still hosts some important meetings, like the British Touring Car Championship, which the Redstone team was attending.

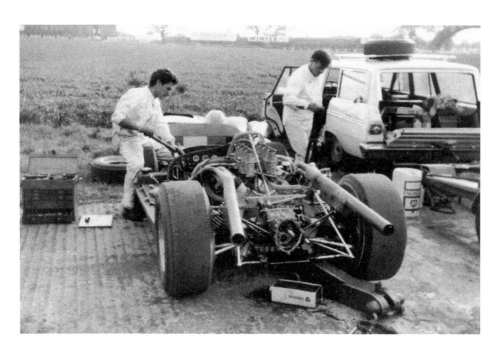

Crops for company

The lack of pit-garages in the 1960s meant that even the high-profile Bruce McLaren, present with his 5-litre McLaren-Oldsmobile sports car at the International Trophy meeting of 1965, had to accept the same primitive working conditions as had obtained since 1952. The fast approach from Abbey to Woodcote is hidden by the crops, beyond which the hangar and half the Dunlop Bridge can just be seen. Below, a Ford Focus, in contrast to the McLaren, enjoys the lap of luxury.

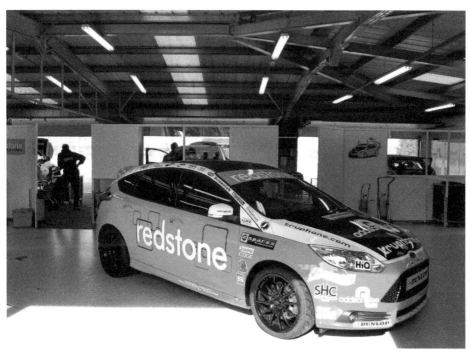

Track Entrance, Mid-Sixties

A Ford Popular in the 1960s waits to gain access to the track via a narrow lane at the back of the paddock leading to the end of the Club Straight. Below, the modern wire fence approximates to the position of its predecessor, as the distant trees confirm. Track access is now via the pit-garages or an outlet by Brooklands. Inset: as single-seaters queue up to go out to the track, Colin Crabbe's ex-Le Mans Aston Martin (DP 214) leads cars returning from a race.

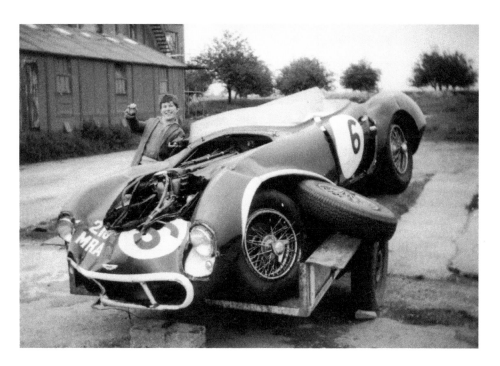

An Expensive Outing

Left on its trailer beside the old control tower and a farm building, this ex-works Aston Martin DB3S was a sorry sight after hospitalising David Eva, who crashed at Maggots in 1965. The driver's wife came to collect the car a week later. Below, the old control tower, now part of a well-kept BRDC enclave. Inset: though the chassis was wrecked, this eleventh and last of the works cars (with its own special aerodynamic headrest) now looks superb again.

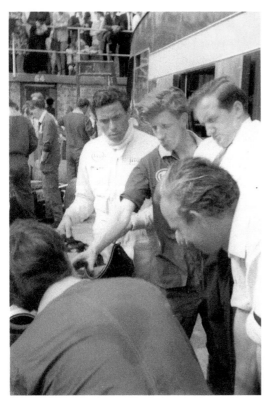

Great Crowd Favourites

Jim Clark in the paddock at the 1967 British Grand Prix, with Colin Chapman (front right). There would seem to be some anxiety over the new, groundbreaking Lotus 49 with the superb Cosworth-Ford engine, but Clark (only a year before his tragic death) was about to win his third consecutive Silverstone British Grand Prix. A sheep farmer himself, Clark always took a professional interest in Silverstone's agricultural endeavours, paying a careful visit one year to the grass-drying machinery with its profitable end product of animal fodder pellets. Below, Nigel Mansell, also a three-time Silverstone Grand Prix winner, whose immense popularity with the crowds was even to eclipse Clark's, driving his Williams-Honda past the farm's grass-drying plant during the 1985 Grand Prix. The massive changes to the circuit of 2010/11 have meant that this part of the track is no longer used.

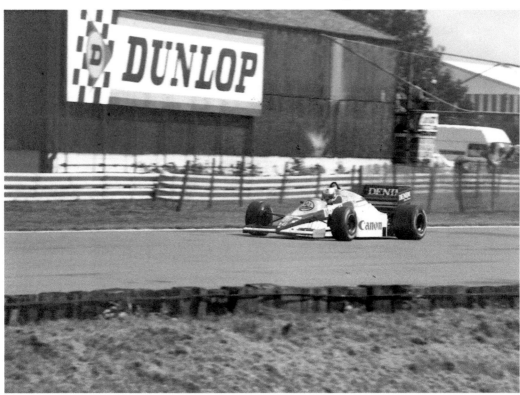

Three Generations

Jack Brabham, World Champion for the third time, is seen in the paddock in his own Formula 2 Brabham in 1967. Brabham loved the high speed of Silverstone ('a wonderful place to go motor racing'), having first known it in all its uninhibited glory in the 1950s. The early exhilaration was something he would never forget, 'reaching speeds I'd never experienced before. And all that space...' Years later he recalled the thrill of the rush down Hangar Straight, 'jockeying for position and trying to get the car placed so I could outbrake Moss into the corner – mind you, I didn't succeed in doing that very often!'

Below, his grandson Matthew drives to the start of a recent Formula Renault race, son of Geoffrey, whose outstanding career included a Le Mans win. Inset, another of Jack's sons, David, also a Le Mans winner. He was racing a Nissan in the 6 Hours of Silverstone race in 2012.

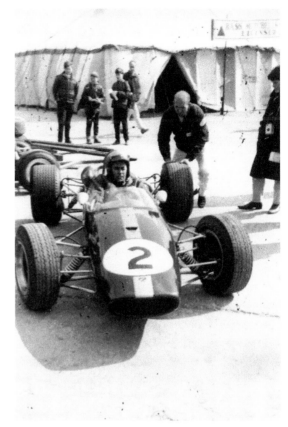

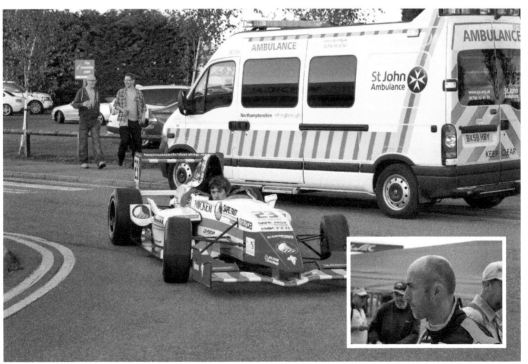

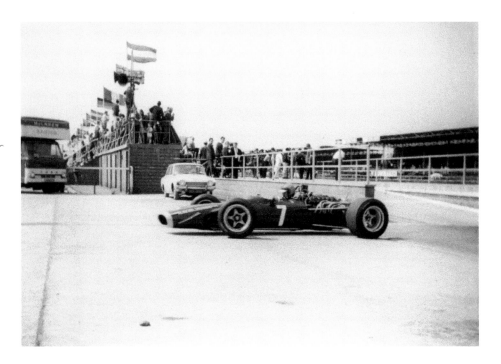

A Bittersweet Sport

Mike Spence (BRM) returns to the paddock at the 1968 International Trophy meeting. The photograph shows the lack of depth in the pits, an inadequacy the capacious Wing, below, so graphically underlines. At that meeting a lone piper on the starting grid played a lament for Jim Clark, a stark reminder that safety standards in motor racing all over the world had fallen well behind technical advances. Spence himself, who inherited Clark's drive at Indianopolis, was killed there ten days later while testing the revolutionary Lotus 56.

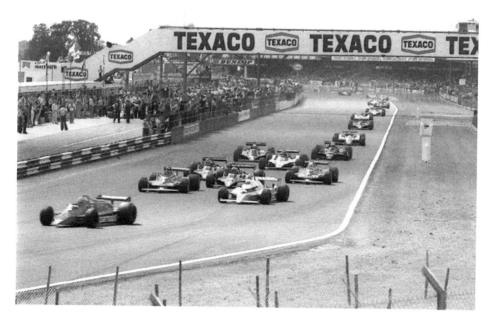

A Big Advance

In 1975 Silverstone at last offered the best drivers and teams in the world the use of pit-garages. They can be seen (background left) as the Grand Prix field of 1979 charges into Copse (Lauda from Arnoux and Villeneuve, the leading four or five having already passed). Few lamented the passing of the old complex (seen below on a test day in 1974). The only loss was the wonderful raised view for those with paddock passes and an ability to push to the front.

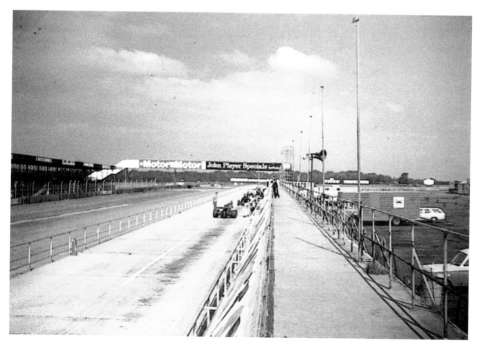

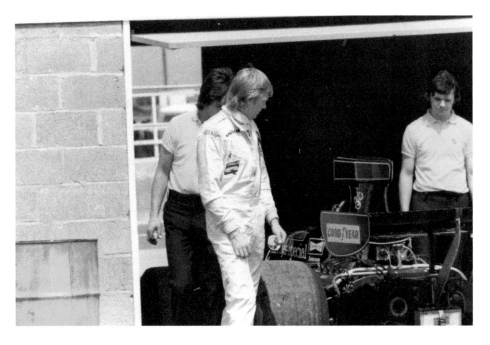

Modest Rapture

The forty-four new pit-garages which replaced the previous twenty units seemed marvellous at the time (a £120,000 development). Above, as Ronnie Peterson eyes his ill-performing Lotus with concern at the Grand Prix of 1975, the pits' new breeze blocks gleam to his right. The garages, in fact, were only 20 feet square. Below, a modern Chevrolet Corvette enjoys rather more space in the Wing, as its drivers at the 6 Hours of Silverstone race, Patrick Bornhauser and Julien Canal, oblige autograph-hunters at a pits walkabout.

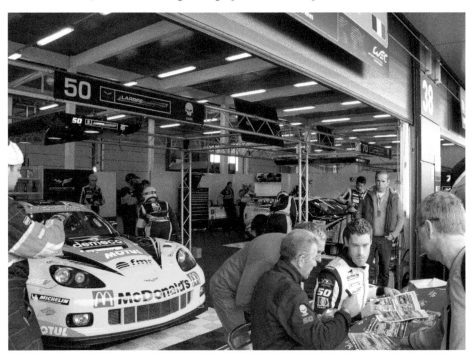

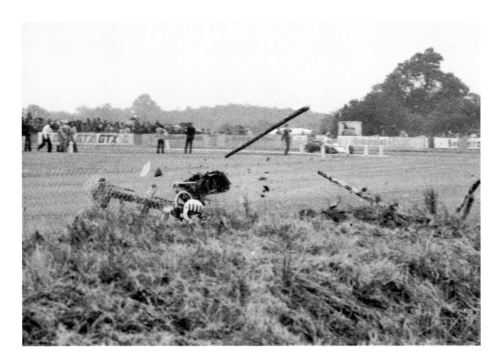

The Age of Catch Fencing

Tom Pryce crashes his Shadow at Becketts while leading the 1975 Grand Prix. Wire catch-fencing, attached to wooden poles by metal staples, had recently been accepted everywhere, Silverstone investing in 4 miles of it for this meeting. There was a downside, however. Tony Brise, having lost his Embassy Hill at Club, was knocked out for several minutes by a flying pole. Below, Brise in the new pit-lane, 1975, shortly before his death in Graham Hill's tragic plane crash.

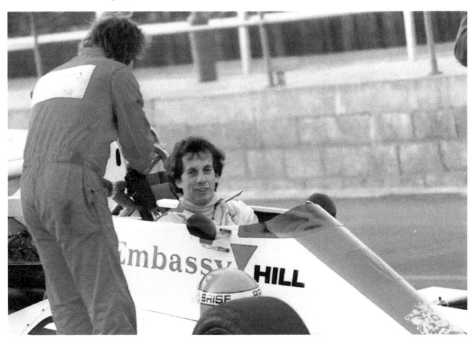

A Need for Screen Idols I

Before the coming of blanket Grand Prix coverage, it was still possible for enthusiasts to get close to the cars and drivers on occasion. Tom Pryce, for example, was photographed in the F1 Shadow while in the pit-lane on a test day from which the public was not excluded. Massive media exposure has now necessarily distanced the drivers from their fans, particularly at the big meetings. Below, Lewis Hamilton is brought a little closer by the big screens.

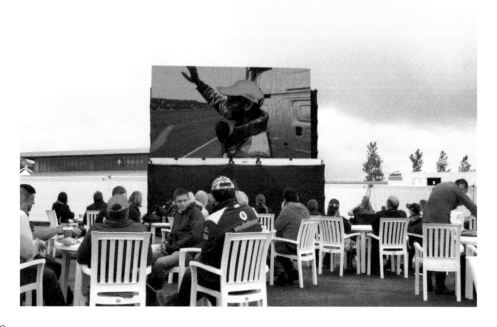

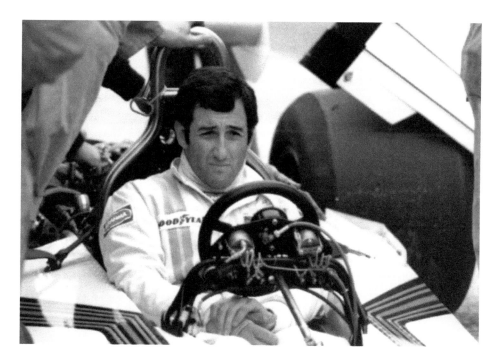

A Need for Screen Idols II

Carlos Pace (after whom Brazil's Interlagos circuit is now named) testing a new Brabham in 1975. For the vast majority of spectators at the Grand Prix of 2012, the closest they would get to stars of the Formula 1 circus like Sebastian Vettel would be on the big screens. Such devices as the one below for Club Silverstone members have become an integral part of the whole entertainment package.

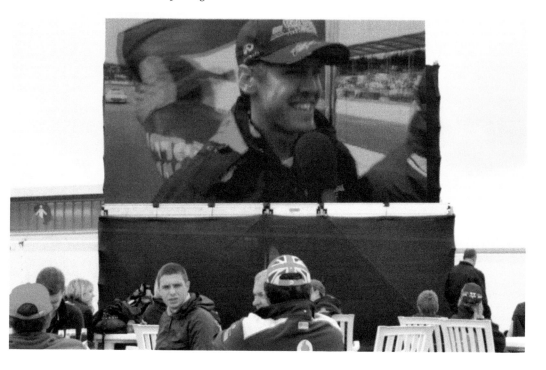

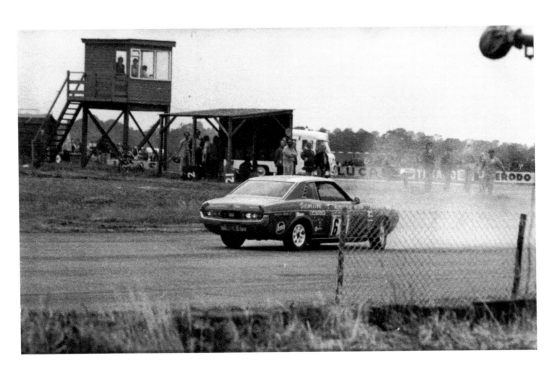

Getting Becketts Wrong

Rex Greenslade is facing the wrong way as he comes out of Becketts in his Toyota Celica in a support race at the British Grand Prix meeting, 1975. Beside the raised observers' hut is the back of a 'leader board', a fairly primitive means of keeping spectators abreast of things. Below, the Toyota subsequently found itself approaching Chapel in a distinctly unconventional manner. Greenslade, who emerged unscathed from what *Autosport* later described as 'a gentle roll', also enjoyed a successful parallel career in motoring journalism.

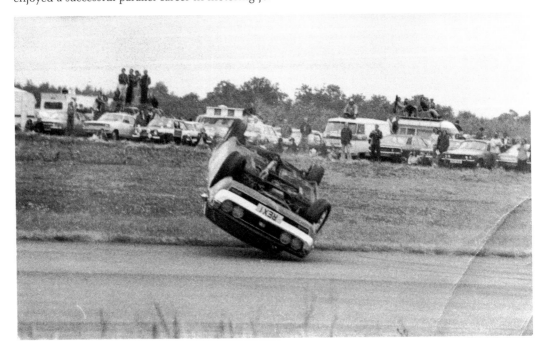

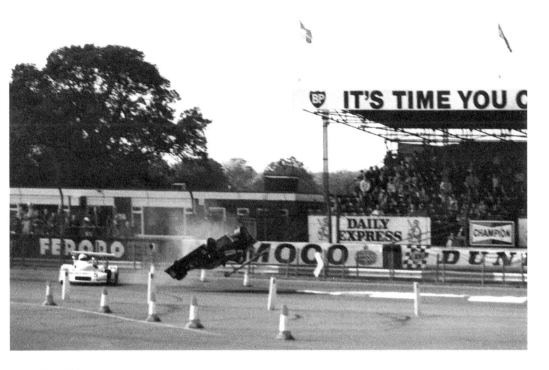

The Chicane, 1975–90

By the early 1970s, if conditions were perfect, top F1 cars would be taking Woodcote flat out at around 165 mph. It was thrilling, but a recipe for disaster, and in 1975 a chicane was installed. Above, a squabble at its entrance, in 1982 in front of the (1967) Silverstone Racing Club. Below, Niki Lauda's Ferrari coming through the chicane in the 1975 Grand Prix, passing the end of the Club Straight. In the distance, the farm and *Daily Express* bridge.

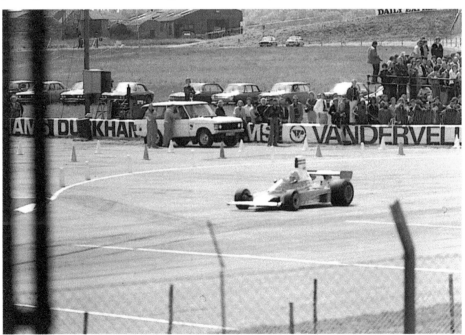

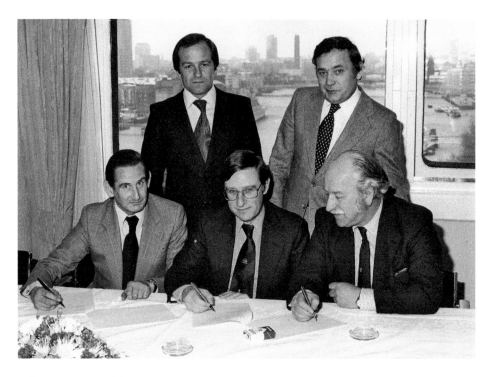

Tobacco Sponsorship

Jimmy Brown (right) signs a new tobacco deal in the presence of three Marlboro executives and in the wake of a previous collaboration with John Player. John Webb of Brands Hatch (left) signs too. The end of this sponsorship deal in 1986 coincided with the end of a twenty-two-year period when the Grand Prix had alternated between the two venues. Brown and the BRDC had won the day. Below, Marlboro flags wave cheerily as the band celebrates a Marlboro Grand Prix.

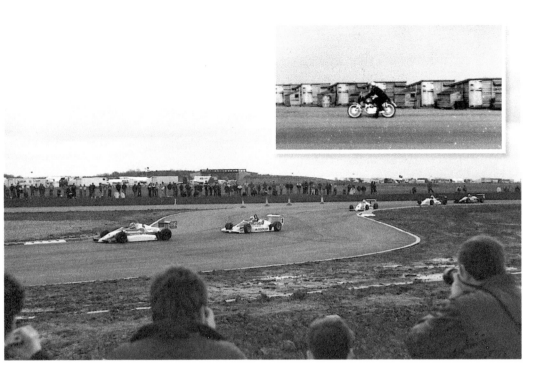

Changing Landscapes

Inset, early on there was a danger of ending up in the henhouses on the flat-out straights before Woodcote. Above, when in 1987 the chicane was thought no longer capable by itself of slowing down the approach to Woodcote, a short-lived left-right diversion was positioned before it. Johnny Herbert and Gary Brabham are seen leading F3s through. Below, the current version of the low-speed infield arena, which in 1990 solved the ongoing problem of Woodcote by a wholesale redesign of the landscape.

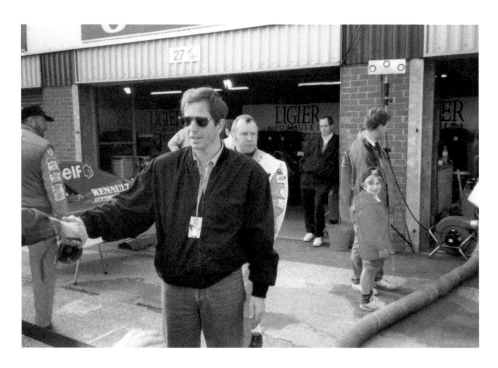

New Pit-Garages I

The securing of the Grand Prix as an annual event was the catalyst for many much-needed improvements; the £1 million scheme of 1986/87, which included the new approach to Woodcote, also created forty new pit-garages, topped by an all-new press centre. Above, Martin Brundle, a Ligier driver in the 1993 Grand Prix, in front of the new pits. Below, the greater space is clearly shown in this late November shot during a recent Walter Hayes Formula Ford Festival.

New Pit-Garages II

Not only were the garages larger than their predecessors, they were interlinked to allow teams greater cohesion. Above, the Ferrari pits during the 1993 Grand Prix. This face-lift of 1986/87 also included the Copse access tunnel; a first bridge over the Club Straight; a wider vehicle bridge at Abbey; new debris fencing and improved spectator facilities. Below, F1 Ferraris in the grassy paddock behind their 'pit', 1958. Mike Hawthorn's blond head is just about visible amid the melée in the centre.

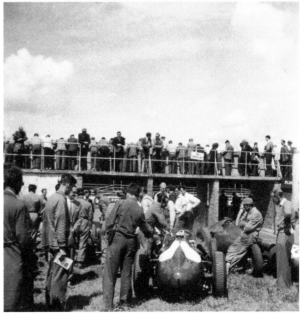

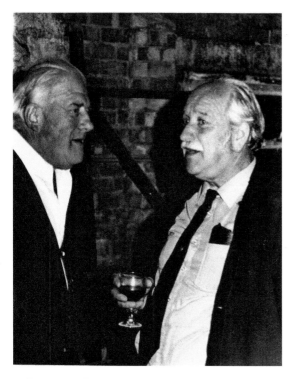

The Jimmy Brown Centre

Jimmy Brown, glass in hand, at a party at the farm with BRDC President Gerald Lascelles. Brown's death in 1988, after forty years' service, was marked by the naming of the new media centre (entrance below) in his honour. Obituaries stressed his no-nonsense approach. 'His unerringly aggressive style – more bark than bite, but you could never be sure – made him a wily negotiator,' wrote Ray Hutton, 'a match for the sharpest wheeler-dealers.' John Pearson, the well-known Jaguar racer and restorer, agrees: 'Yes, Jimmy could get cross, but he never bore grudges. And he knew how to deal with people, all types of people. Fair to everyone, he really looked after his loyal helpers. Silverstone would be nothing without Jimmy and Kay. She was brilliant, happily hauling bales of straw and knocking posts into the ground! And Kay knew how to handle Jimmy – perhaps the only person that did.'

Soon after Brown died, a new five-year Grand Prix contract was secured, but dependant on big improvements in both amenities and safety. Three changes were particularly bold. First, the Woodcote chicane was abolished, replaced by a fast and excitingly landscaped new right-hander, Bridge Bend (*see p. 27*), leading into an arena complex of three further bends – Priory, Brooklands and Luffield. Secondly, to slow the cars at Club (a flat-out corner with limited run-off), the exit from Stowe was tightened and an infield diversion created leading to a new left-right called Vale. Thirdly, to ease pedestrian congestion behind Becketts the corner was moved inwards, becoming part of a series of fast curves from Maggots to Hangar Straight. The new circuit, now a little longer at 3.2 miles, was officially opened in 1991. As Formula 1 supremo Bernie Ecclestone cut the red tape, fireworks blazed over Woodcote.

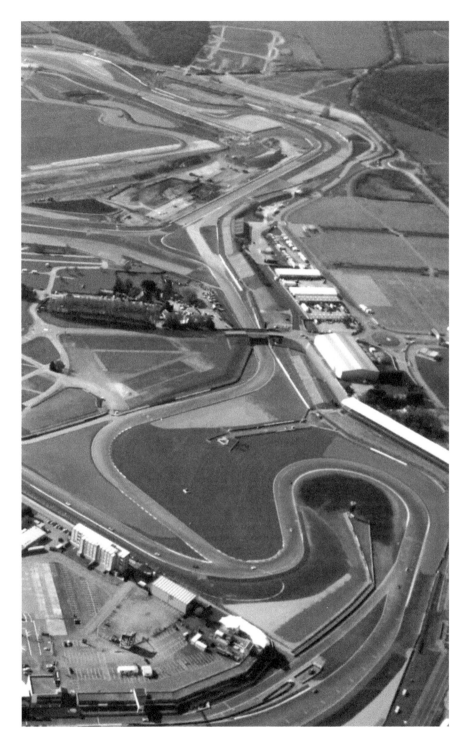

New Arena

The new arena of corners after the bridge, created in 1991, destroying the old Woodcote but safeguarding the circuit's future.

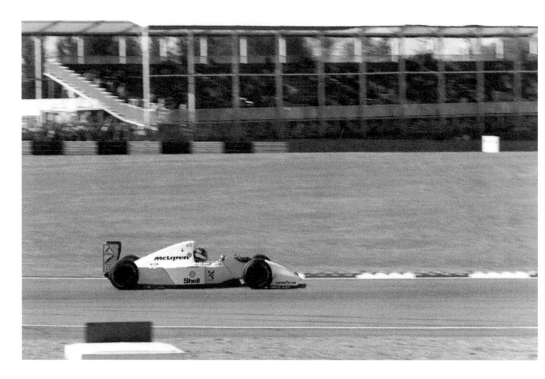

Senna in the New Arena, 1993

Senna's McLaren, having just taken the right at Bridge and the left at Priory, is heading for Brooklands on a road parallel with the Club Straight. In the background is a new grandstand, situated between Bridge and Priory. The area where this whole complex was created, on the west side of the Club Straight, was once empty fields, as the rare photograph of the 1960s shows. The enclosure opposite contains a clubhouse for the Motoring Writers' Guild and, beyond, a drivers' changing room.

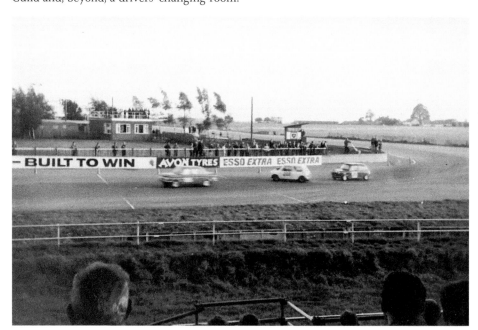

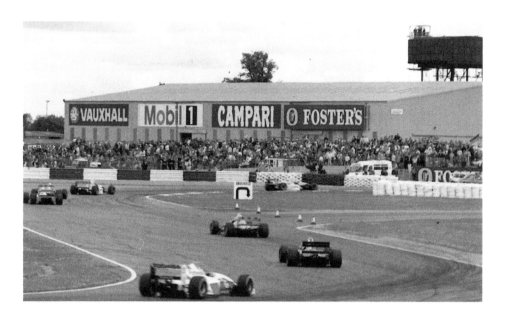

Brooklands to Luffield, 1993

Damon Hill leads Williams teammate Alain Prost and the Grand Prix field round the new arena complex, passing the old hangar and water tower (which is providing a precarious viewing platform). Below, the same hangar and tower, together with some shadowy nissen huts, offer a similar background to two Jaguars fighting for the lead in a club race of 1963, cornering towards the pits from the old Club Straight, past the site of the future chicane...

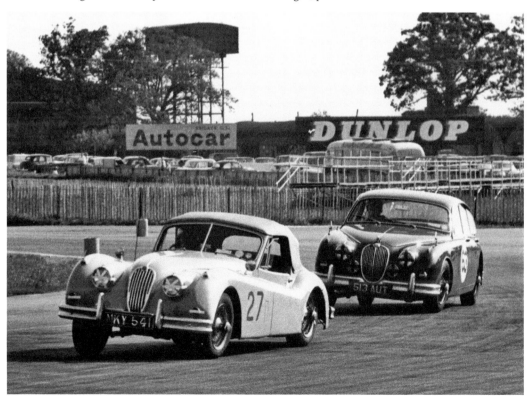

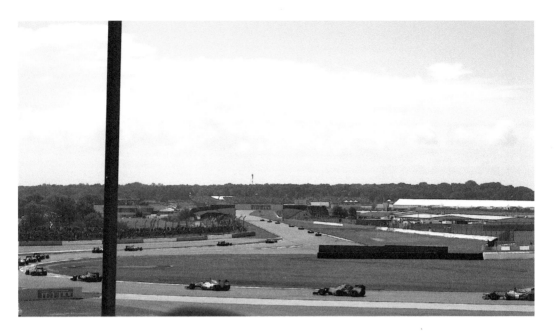

Becketts Resculpted

Most corners have enjoyed steady re-profiling in the cause of safety or better flow, the changes to Becketts in 1991 being very typical. The high-speed curves all the way from Maggots via Becketts to Chapel – being experienced (*above*) by the Grand Prix field of 2012 – were the result of this major reconfiguration. Below, now sited well behind the grandstand, this old piece of the apex of Becketts reveals just what a difference to the corner the alterations of 1991 made.

Entertainment and Change

The Brooklands hospitality unit of 1994 (*above*) brought into play a 180-seat restaurant, ten hospitality suites and views over the new arena complex. It currently offers a first-floor Executive Suite for up to 200 guests. The unit now looks down upon an altered arena fed by the Wellington Straight. The track in the foreground, down which Senna drove his McLaren (*p. 78*), is no longer in use. Below, spectators enjoy their day out in an era before corporate entertainment.

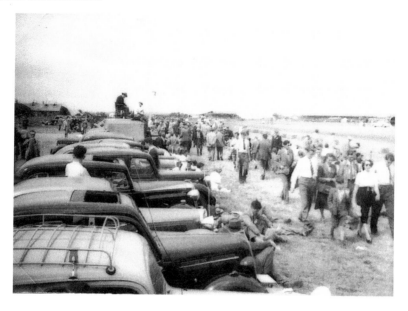

Blanket Television

A single television camera at Copse, helping a Grand Prix reach many millions, symbolises the high-tech expertise and big-business ambition of the F1 circus. Silverstone, unbacked by government subsidy, has understandably struggled to keep up in the flurry of exotic, money-no-object circuits sprouting in idyllic travel-brochure destinations. But it has gallantly held on and, as the ensuing pages demonstrate, the improvements of 2010/11 have quite outstripped anything in the past. Further advances would seem contingent on imaginative diversification and burgeoning business partnerships.

Below, temporary television gantries of another era can be seen (about to be replaced by the Dunlop Tower of 1967). No cameras in action, of course, at this particular club meeting, which seems to have come to a halt as a crashed car is carefully retrieved by two local breakdown trucks. It was only in the 1980s that blanket motor racing coverage took hold, aided by the Murray Walker and James Hunt F1 show.

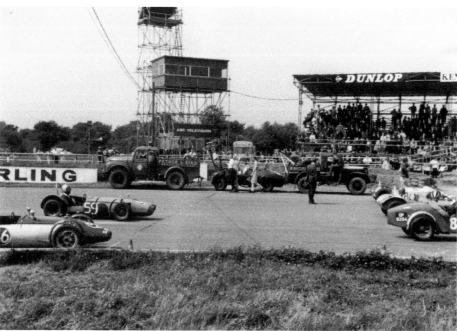

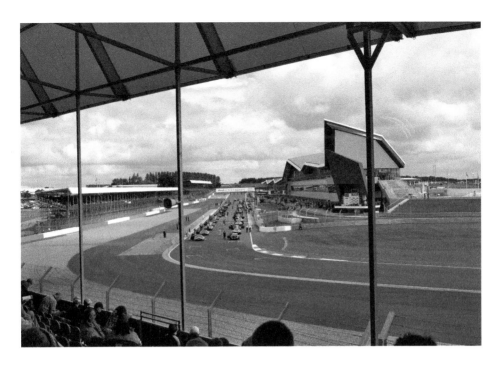

The New Start
Club Corner's view of the new International Pits Straight, faced by the Wing, the spectacular £27-million centrepiece of the huge development package of 2010/11. Its length (390 metres) and height have allowed some 2,000 square metres of conference space and 4,000 for exhibitions, in addition to all the ample garages, media centre, race control and hospitality areas. Below, another start-line in another era: the beginning of a 1956 relay race, with the old timekeeper's bus put to new use. (Simon Lewis Transport Books)

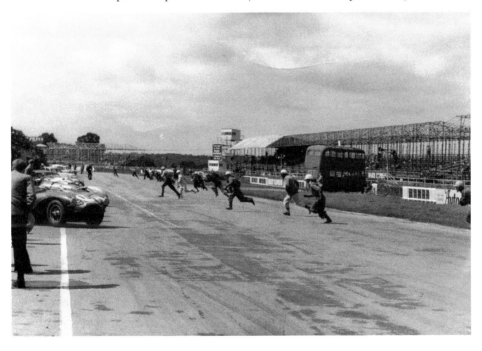

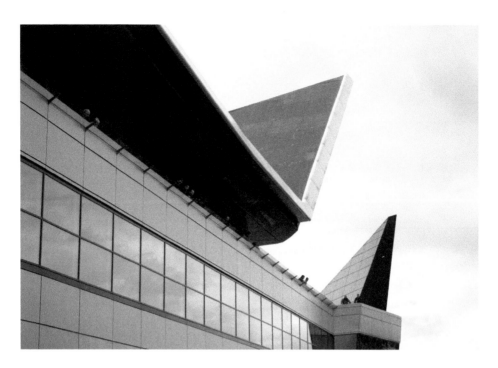

Twin Heartlands

Populous, the Wing's architect firm, was given two key themes: 'flight' and 'velocity'. 'The building's dramatic, continually changing roofline responds to the speed and tension inherent in racing itself,' they commented on completion. 'Its end-point, at the new circuit's final corner, reaches towards the skies.' This end-point is just visible from the BRDC's clubhouse (*below*), situated in the circuit's old heartland. Silverstone's future, one suspects, will be all about unleashing the possibilities inherent in one circuit having two heartlands.

Abbey's New Direction

In the major alterations of 2010/11, Abbey curve was rerouted to the right of the farm (now hidden behind a metal barrier). As Mike Hawthorn's D-type Jaguar of 1955 shows (*below*), it had always swept to its left. This route can now be used by fans coming in from the Dadford Road car parks. The grandstand to their right, in shadow, is that of the new Abbey corner (the second of the two grandstands on the left in the photograph of the modern start-line, *see p. 82*).

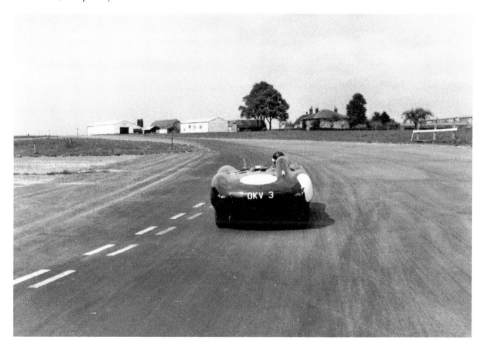

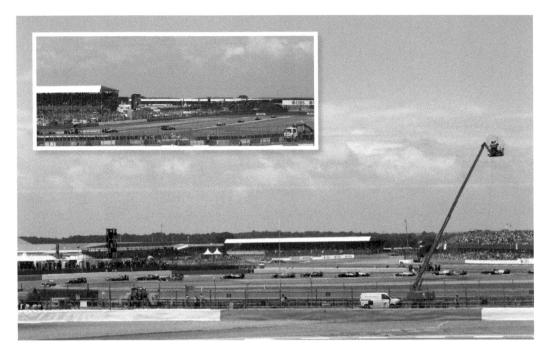

The New Post-Abbey Complex

The view from Becketts to Abbey (the grandstand in the far distance with the white roof). Abbey and the corners which immediately follow it (Farm Curve, Village and the Loop), first used in 2010, are shown in 2012 with Alonso's Ferrari in the lead. Inset: the cars exit this complex via the old Club Straight which takes them under the bridge and into the Brooklands-Luffield-Woodcote arena. Below, a Formula 5000 (Jock Russell's Leda) rounding a much more rustic Becketts in 1973.

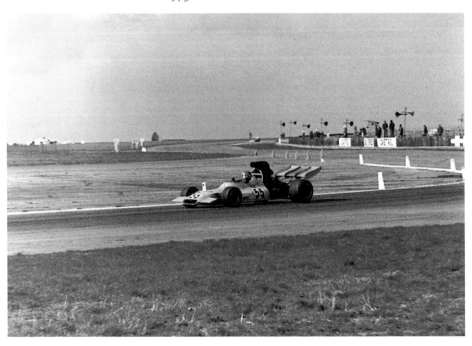

'The International Circuit'

A small link between the new Village corner and Chapel was all that was needed for Silverstone to have two independent circuits, operational at the same time. The northern half was renamed the National Circuit and the southern (taking in the Wing) was named the International. The full circuit is now the Grand Prix. While a race meeting goes on close by on the National Circuit, a 'Driving Experience' Ferrari (*above*) and Renault Megane (*below*) round the International Circuit. A wide variety of such experiences are on offer.

The Stowe Circuit

Back in 1987 a small internal track was created, a 'South Circuit', for testing purposes and use by the revamped John Watson Performance Driving Centre. So today's Silverstone also has a fourth circuit, neatly situated within the southern infield, utilising parts of two old runways. Cars on this 1-mile track ('Stowe Circuit') can be seen in the distance above, as three tracks are in simultaneous action. Below, one of the training circuit's inviting single-seaters.

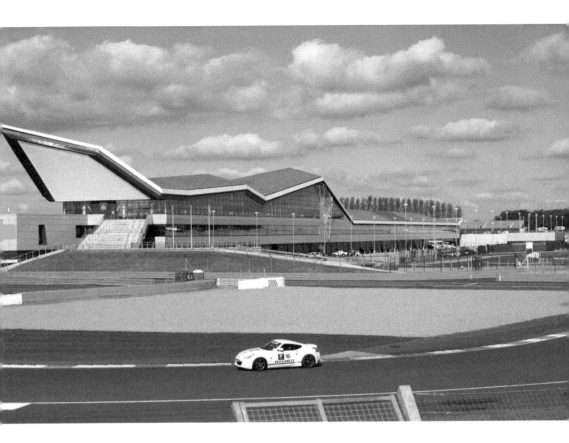

The New Landmark

A 'Nissan Academy' car approaches Club from Vale. Whether or not the Wing truly expresses 'the grace of a bird's wing in full flight' (as has been suggested), it is certainly the most important single building ever to be erected at Silverstone. And with such arresting looks, it is easily recognisable the world over. Below, Bernie Ecclestone's 500cc Kieft in the paddock, 1953, when he was a young, ambitious racing driver. Would the Wing exist today but for him?

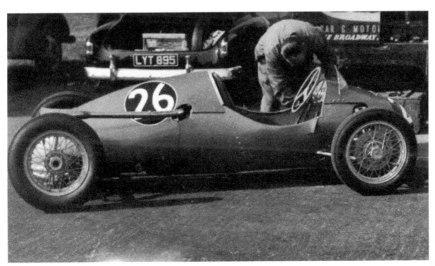

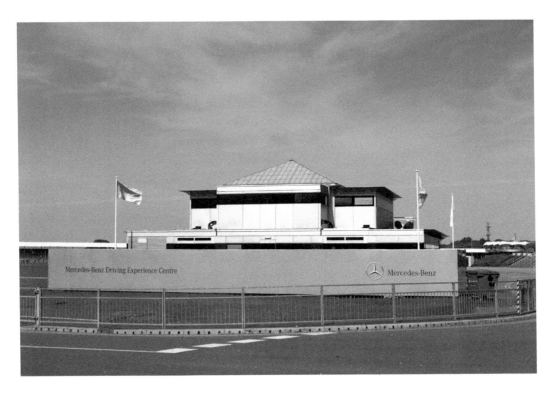

Mercedes Splendour

Mercedes' splendid Driving Experience Centre, situated in an area opened up to the general public by the track changes of 2010/11, is an appropriate reminder of the company's proud racing heritage. Below, a snapshot of the manager of the Mercedes team, the formidable Alfred Neubauer, in 1954. The new Mercedes W196 with its all-enveloping bodywork was expected to sweep the board at the Grand Prix that year just as it had recently done in France, but the team had a real struggle, even the great Fangio having problems with Silverstone's oil drums. It was, however, only a temporary glitch...

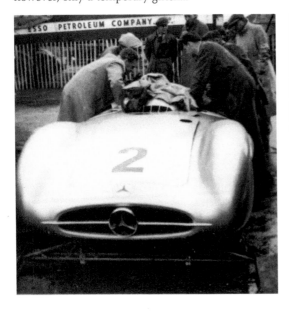

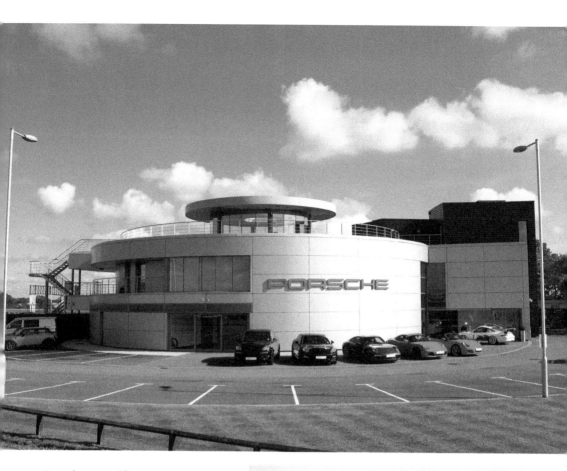

Porsche Magnificence

On the other side of the circuit, Porsche's Driving Experience Centre, opened in 2008, boasts similarly attractive modern architecture, adventurous and uncluttered, yet managing to articulate a flavour of the old airfield. The adjacent Porsche circuit is equally impressive. It is all part of modern Silverstone's determination to diversify, a diversification that soon promises to include a university college and a deluxe hotel. Below, a contrast to Porsche magnificence, a somewhat battered MG in the 1960s and, behind it, the Dunlop International Racing Service hut, somewhat prosaic architecturally, yet one of the most important buildings in the old paddock.

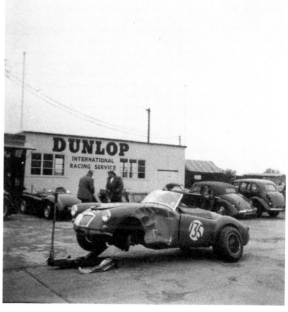

Silverstone Mud

Well-publicised problems remain, as the circuit continues its efforts to fund improvements which will keep it in line with its international competitors. Summer sunshine, alas, cannot be relied upon, and impassable conditions in the grass car parks have caused much recent heartache. It is not a new problem. Below, these enthusiasts at Copse at the International Trophy of 1964 probably took the mud totally for granted.

Silverstone Gravel

Huge improvements have taken place in spectator comfort, though of course there is scope for more. This spectator terrace, for example, still has a makeshift air. But it's a vast site, and ever since the BRDC purchased it from the Air Ministry in 1971 (and thereby secured its future), the funding of improvements has always been a stern challenge. Below, in 1964 those outside the grandstands really struggled for a good view. It was helpful to bring along a stepladder.

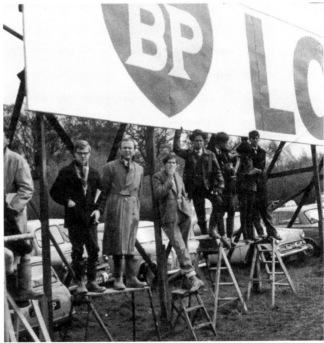

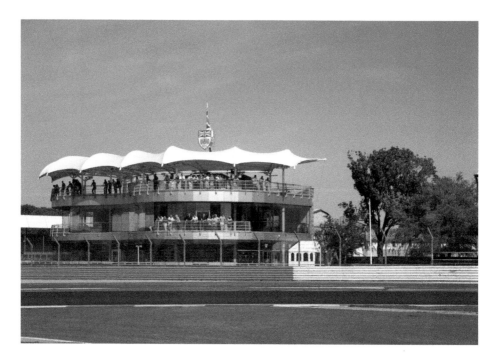

The Heart of the Circuit I

The BRDC's charming clubhouse, opened in 1999, was designed by the London-based architect firm Populous, also responsible for the Wing as well as Arsenal's Emirates Stadium, Wembley, the O2 Arena, Ascot and the London Olympic Stadium. Commanding wonderful views over the circuit, it exemplifies the bold ambitions which have motivated the startling developments of the recent past. Below, its predecessor, which was built onto the Guild of Motor Writers' base (*see p. 78*) in 1980, with long-serving stewards Gordon and Alan Blackwell and David Wesley.

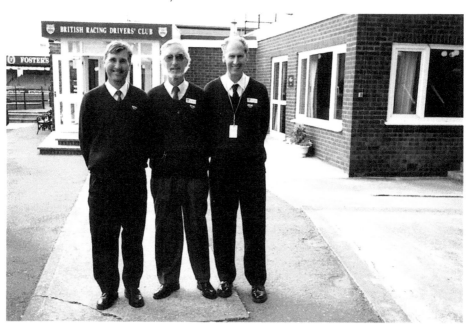

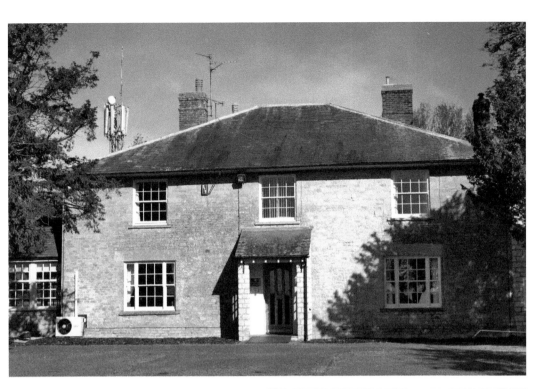

The Heart of the Circuit II

Luffield Abbey Farm, currently housing the BRDC's archive and library and dating back to the seventeenth century, has long been at the centre of things. In wartime it stood by the runways, witnessing flight after flight, its barns housing vital things like tractors with floodlights on trailers; night-flying equipment; salt and sand; and the all-important fire tenders. It was from here, when peacetime returned, that Smith and Brenda Churchill re-established the farm, and Jimmy and Kay Brown later oversaw the needs of the fledgling track. Maybe one day both farm and neighbouring control tower, restored to their past glories, will act as some kind of memorial to both the bravery of the aircrews who trained at Silverstone and the doggedness of those who worked so relentlessly to give British motor racing a fitting home. Below, a relaxed Smith Churchill, outside the farm in 1947, is plucking a duck.

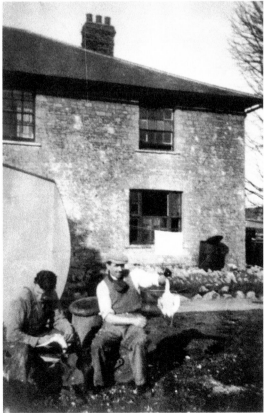

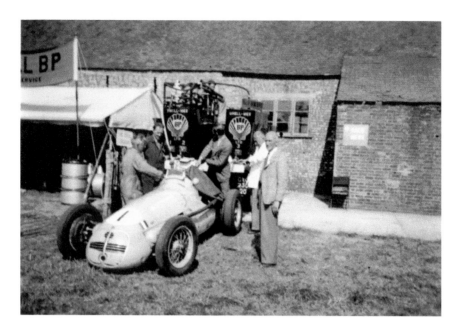

Bira's Maserati being fuelled at the farm, 1949 Grand Prix. (Photograph: Smith Churchill)

Acknowledgements

The text, written by Anthony Meredith, owes much to Gordon Blackwell's deep knowledge of the place. Gordon Blackwell has likewise been instrumental in the acquisition of much previously unpublished illustrative material. Photographs have been generously lent from the collections of Andrew Clarke, David Wesley, John Pearson, Ian Gittins, Terry Foley, Tony O'Gorman, Richard Palmer, Ivy Cakebread MBE, Graham Churchill, Simon Lewis and Ted Walker. Grateful thanks also go to British Racing Drivers' Club and Michael Hammond of the Guy Griffiths Collection, as well as James Beckett, Geoff Blackwell, Jonathan Blackwell, Hamish Brown, Ian Brown, the *Buckingham Advertiser*, Robert Carter, Brian Dovey, Chris East, Josephine Edrich, Sandy Fage, Alan Gittins, Sarah Greenwood, Paul Harris, Duncan Hyslop, Gerald Lovell, Heather Meredith, Michael Meredith, Gavin Moore, Elspeth Mullineux, Brian Pallett, Joe Pettican, Stuart Pringle, Geoffrey Purefoy, Ron Roberts, Stephanie Sykes, Andrew Walton, Liz Zettl and the admirable Silverstone village website. Helpful books have included *Silverstone: An Historical Mosaic* (ed. Martin Marix Evans, 2001); *Memories of Old Silson* (Pamela Raynor, 1998); *Silverstone* (Peter Carrick, 1974); *Northamptonshire Airfields in the Second World War* (Graham Smith, 2004); *Pole Position* (BRDC, 1987); and *Silverstone: Fifty Golden Years* (BRDC, 1998).